IMAGES
of America

POCOMOKE CITY

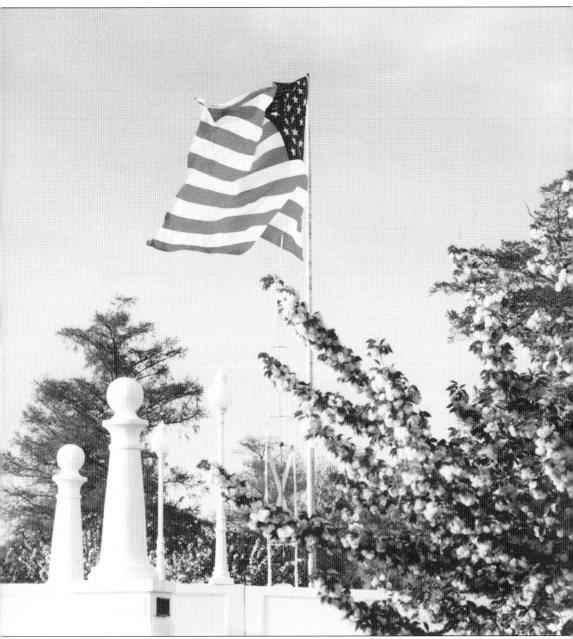

The Pocomoke River drawbridge, completed in 1921, is a beloved symbol of the town. It was rebuilt in 1988 following a devastating collapse. (Photograph by John C. Brinton.)

ON THE COVER: The arrival of the railroad in Pocomoke City brought new markets for fruit and vegetable growers. In this 1930s image, tomatoes are readied for processing at the Mason Canning Company on Clarke Avenue. Ralph Mason founded Mason Canning in 1925. By the 1950s, the company was processing tomatoes, sweet potatoes, and white potatoes and included a feed division that distributed food for poultry and dogs. More than 200 people were employed during the peak summer season. (Courtesy of the Preston and Mary Marshall estate.)

IMAGES
of America

POCOMOKE CITY

Norma Miles and Robin Chandler-Miles

ARCADIA
PUBLISHING

Published by Arcadia Publishing
Charleston SC, Chicago IL, Portsmouth NH, San Francisco CA

Printed in the United States of America

Library of Congress Catalog Card Number: 2007937763

For all general information contact Arcadia Publishing at:
Telephone 843-853-2070
Fax 843-853-0044
E-mail sales@arcadiapublishing.com
For customer service and orders:
Toll-Free 1-888-313-2665

Visit us on the Internet at www.arcadiapublishing.com

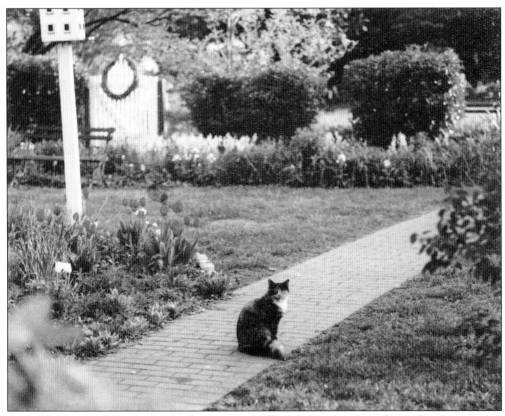

A neighborhood cat enjoys a sunny afternoon in the Hall-Walton Garden. The garden abuts Costen House, the restored residence of Pocomoke City's first mayor, Dr. Isaac Costen. (Photograph by John C. Brinton.)

CONTENTS

ACKNOWLEDGMENTS

Many people, businesses, and organizations contributed to this Pocomoke City pictorial. The Spirit of Newtown Committee and the Sturgis One Room School Museum generously opened their archives to us. The Delmarva Discovery Center contributed priceless images and information. Minute Man Press, Advantage Color Lab, and Susan Taylor at the Calvin B. Taylor Foundation provided invaluable reproductions of vintage materials. We also wish to thank Mary Spide, Evelyn Hancock, George Henderson, Barbara Hickman, Robert Hawkins, and Choppy Layton for photographs and information. Joe Mel Byrd, E. A. Hall, Beulah Baylis, Brice Stump, Judy Krabill, Darlene Dean, Bill and Kate Matthews, the Preston Marshall family, and the Scher family really came through for us. Special thanks go out to Winnie Small, Mickey Wigglesworth, William Kerbin, and Carol Brittingham Wilkes for the materials they provided.

Paula Sparrow and town manager Russell Blake took time out of their busy schedules at city hall to locate long-lost photographs and other media; we are very grateful. Earlier research on Pocomoke City by Eben Hearne, Elmer Brittingham, and Rev. James Murray was meticulous and complete, allowing us to borrow liberally from their works. Mayor Mike McDermott, one of our town's greatest ambassadors, used his weekly radio show to get the word out about our project and the need for materials; we appreciate his efforts. The number of people who entrusted us with original vintage images was astounding, and we will never forget their votes of confidence.

We owe a great debt to our families and friends for their patience and support and to the people of Pocomoke City, who never failed to inspire us.

Seen here are the authors, Norma Miles (left) and Robin Chandler-Miles.

INTRODUCTION

Pocomoke City and the river it hugs are synonymous. It was the river that brought the earliest inhabitants to its banks, and later it was the river that allowed commerce to flourish.

Capt. John Smith and his party navigated and charted the river as early as 1608. Native American descendants of the Algonquin tribe were living along the river then, enjoying the mild climate and the river's bounty. By the 1700s, the Algonquin population had moved north, and settlers soon replaced them. From Virginia and later from Lord Baltimore's Maryland Colony, groups of hardy and ambitious men began to stake claims to land on the Eastern Shore. With the evolution of Colonial enterprise, a ferry crossing was established along the river and growth began in earnest.

The Pocomoke River area, home to countless varieties of reptiles, birds, and plants, became a haven for bootleggers, smugglers, and Underground Railroaders as well as diligent settlers. With the passage of time and the advent of river shipping, brick making, lumbering, and shipbuilding trades all flourished. As people came to the area to work, they brought their families and found that this peninsula, nestled between the Atlantic Ocean and the Chesapeake Bay, was a great place to live.

As the years passed, it remained this way. Ruth P. Mathias, a secretary at the Pocomoke City Chamber of Commerce in 1956, wrote a brochure detailing life in the town:

> Take a temperate climate, plenty of space and fresh country air, mix with farmland, forest, rivers, creeks and streams and you have all the elements of pleasant living. Worcester County offers all of these to the wage earner and the millionaire in equal measure. Good schools, recreational facilities and, most of all, the great outdoors make it an ideal background for children. There is an Eastern Shore saying "Once you get the dirt of the Eastern Shore in your shoes you are never content any other place." We have seen this happen in many, many cases, not only of people who have moved away and came back here to retire, but people who have sought employment in other organizations and fields of endeavor, rather than be transferred elsewhere.

Speaking as your authors, we both grew up in Pocomoke City. Some 30 years separated our experiences, and yet they were very much the same; we both enjoyed a family-friendly town with active civic organizations powered by hardworking people. Our public schools were excellent and received a lot of community support. We had local churches of many denominations, all cordial and welcoming. We had a golf course, baseball leagues, and a grand theater for entertainment. We had a public library as early as 1930, started by the Woman's Club of Pocomoke City and financed by the town and by public subscription. We had the river—to navigate for pleasure and to fear for its rumored depth and murkiness. We both gathered on Market Street and stood on tiptoe—or on the high steps of Bethany Methodist Church—to see the floats and firemen as they passed by in countless parades. We spent our nickels and dimes at Woolworth's and J. J. Newberry's. People we love were married here, in gardens fragrant with lilacs and dotted with gazebos or in beautiful church sanctuaries. We buried our friends and families in the neat cemeteries that bookend the town. Pocomoke City embraced us both, and we in turn embraced Pocomoke City.

The town has experienced many challenges. On at least three different occasions, fire ravaged the downtown area, while economic downturns threatened prosperity. In 1996, the toxic organism *Pfiesteria* invaded the Pocomoke River, resulting in severe fish killings and a concern that humans could be affected. The town's drawbridge, the familiar and much-loved gateway into Pocomoke City, collapsed into the river at a time when many feared Maryland's budget crisis would prevent its restoration. A quick glance through an old town newspaper shows the good and the bad; on the same page as a business closing or an accident, there is mention of a new enterprise or an achievement award given to a community member. The town rises, falls, rises again, and continues to flow along—just like the river.

When we began compiling images and information for this book, the community response was amazing; albums were opened, drawers emptied, and memory banks challenged. Some people took photographs right off their walls and entrusted them to us, vintage frames and all. Delving into old albums, newspapers, and club records is time consuming, though all gladly did it. The people whose town we were trying to represent wanted us to have the right dates, the most accurate information, and the best images. We met with people in restaurants, public libraries, offices, and homes. One dear lady, the now late Aubrey Davis, fixed us a delightful meal and spent hours sharing information with us.

Pocomoke City has survived and continued to grow through the efforts of the people who live and work there. We hope these images will provide the reader with a glimpse into the life of the town and help to preserve its unique history.

One

LAND OF DARK WATER

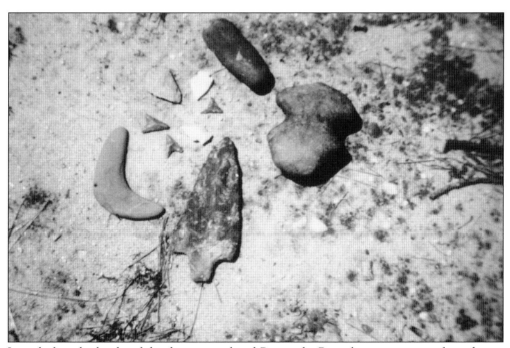

Long before the banks of the deep, tea-colored Pocomoke River became a center for industry, descendants of the Algonquin Indian tribe settled there. The climate of what is now known as Maryland's Eastern Shore was moderate and food was plentiful. The Algonquin word *Pocomoke* was believed to mean "dark water," but scholars now think it translates into "broken ground." Shown here are some of the hunting and farming artifacts left behind by the Native Americans who lived along the river. (Courtesy of the Ferher Collection.)

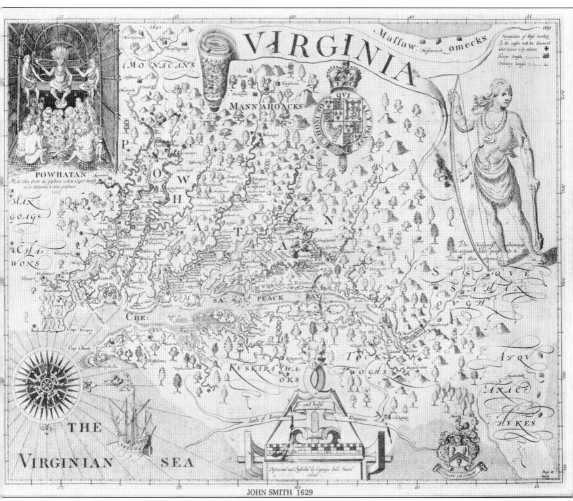

English explorer and adventurer Capt. John Smith sailed up the Pocomoke River while navigating the rivers that emptied into the Chesapeake Bay in 1608. The river, originating in the Great Cypress Swamp near the Delaware border, is 73 miles long with depths ranging from 7 to 45 feet. It is the easternmost river flowing into the Chesapeake and is thought to be one of the deepest rivers for its width in the world. Captain Smith published this map of his voyages in 1612; it was later used to determine the boundaries of the early colonies. (Courtesy of *Altases and Early Maps of the Eastern Shore of Maryland, 1877.*)

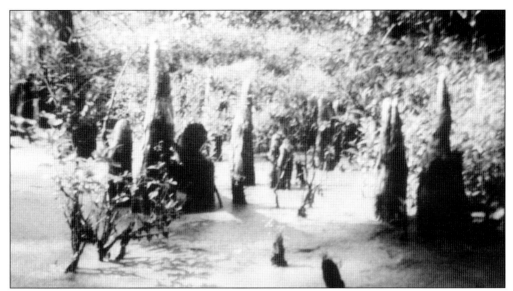

The trees that shadow the Pocomoke River comprise the country's northernmost bald cypress swamp. The tannic acid secreted by the roots of the trees is believed to contribute to the river's murkiness. Cypress "knees," seen peeking above the surface of the water, are thought to contribute oxygen to the tree's root system. Bald cypress trees can live for more than 500 years and grow over 100 feet tall. (Courtesy of the Ferher Collection.)

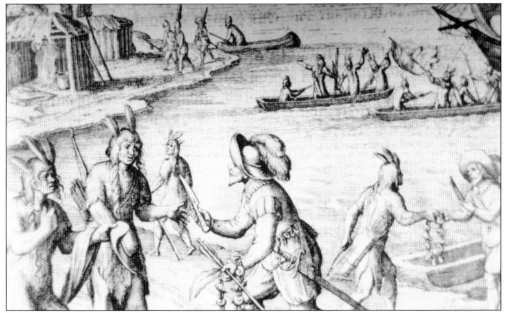

This image represents early traders interacting with Algonquin Indians along the river. Traders desired the skins and pelts that the tribe could provide in exchange for whiskey, cloth, metal tools, and firearms. The Native Americans who made their home along the Pocomoke River enjoyed a peaceful existence and usually maintained an amicable relationship with the traders and settlers. Disputes occurred when the settlers tried to establish boundary lines and property rights that the Algonquins could not comprehend, as their existence depended on living and hunting wherever conditions were most suitable. (Courtesy of the Ferher Collection.)

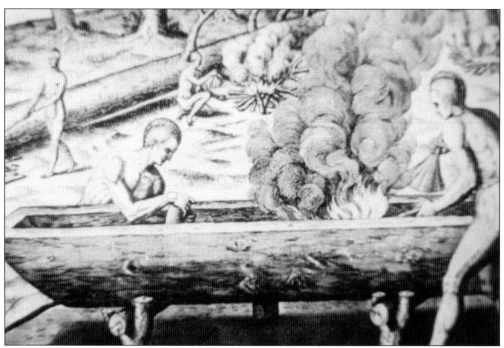

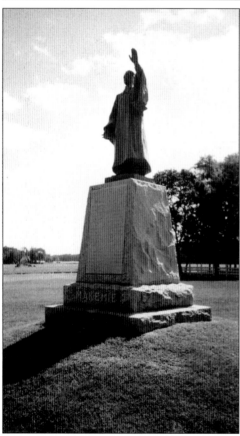

Native Americans continued to live along the riverbank until colonization by English settlers forced them to scatter. Here members of a tribal settlement make use of the area's rich resources. Early canoes such as this one were reportedly used to traverse the river and to gather shellfish that could be stored nearby for use during the cold winter months. In 1632, King Charles I of England granted the Maryland charter to the first Lord Baltimore, and the initial settlers arrived in Maryland in 1634. In 1670, Lord Baltimore sent Col. William Stevens to claim and develop rural land. Colonel Stevens established a ferry crossing along the banks of the Pocomoke River; the area thus became known as Stevens' Ferry. (Courtesy of the Ferher Collection.)

The ferry landing brought trade, and increased trade lured people to the settlement. In 1682, Presbyterian minister Francis Makemie came to the area, and a house of worship was built. Stevens' Ferry became known as Meeting House Landing. In Sanford, Virginia, some 12 miles south of Pocomoke City, a monument remembers Reverend Makemie as "the chief founder of organized Presbytery in America, A. D. 1706." (Courtesy of Chris Miles.)

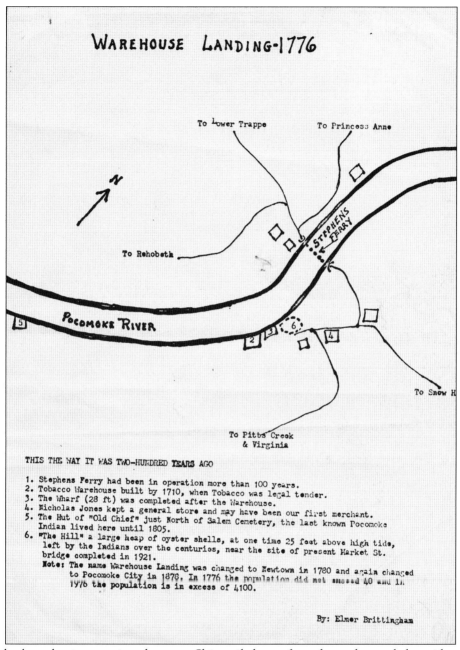

WAREHOUSE LANDING-1776

To Lower Trappe

To Princess Anne

To Rehobeth

STEPHENS FERRY

N

POCOMOKE RIVER

5

2 3 6 4

To Snow H

To Pitts Creek
& Virginia

THIS THE WAY IT WAS TWO-HUNDRED YEARS AGO

1. Stephens Ferry had been in operation more than 100 years.
2. Tobacco Warehouse built by 1710, when Tobacco was legal tender.
3. The Wharf (28 ft) was completed after the Warehouse.
4. Nicholas Jones kept a general store and may have been our first merchant.
5. The Hut of "Old Chief" just North of Salem Cemetery, the last known Pocomoke Indian lived here until 1805.
6. "The Hill" a large heap of oyster shells, at one time 25 feet above high tide, left by the Indians over the centuries, near the site of present Market St. bridge completed in 1921.
Note: The name Warehouse Landing was changed to Newtown in 1780 and again changed to Pocomoke City in 1878. In 1776 the population did not exceed 40 and in 1976 the population is in excess of 4100.

By: Elmer Brittingham

Trade along the river continued to grow. Ships sailed away from the settlement laden with pelts, tobacco, and lumber and returned from the West Indies or southern ports with coffee, rum, and exotic fruits. In the early 1700s, a tobacco warehouse was built along the banks of the river. With tobacco accepted as legal tender, planters could deposit their crops there and write drafts against them to pay debts or make purchases. This map depicts the area near the ferry landing as it likely appeared in 1776. Renamed Warehouse Landing, the site includes a constructed wharf and small general store. The map also illustrates an area known as "the Hill," a towering heap of oyster shells left by Native Americans over the centuries that served as a landmark along the riverbank. This map was drawn by local historian Elmer Brittingham in 1976.

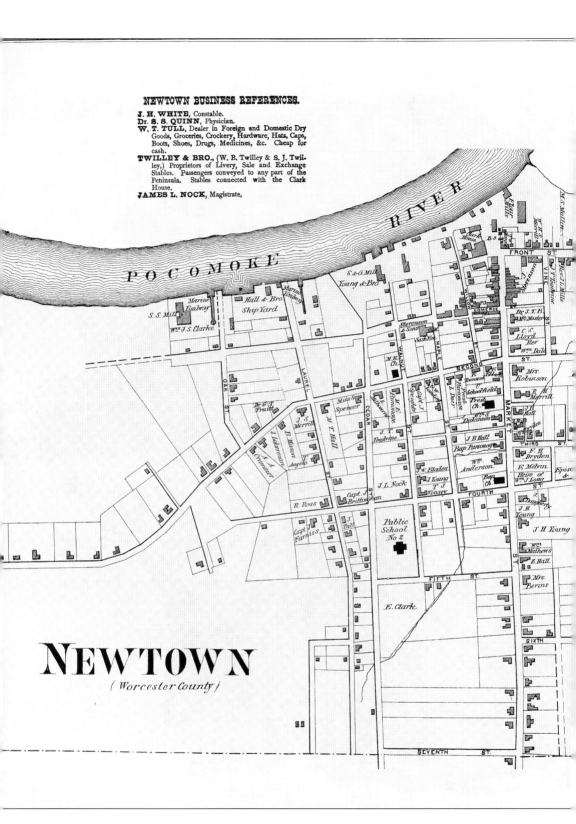

NEWTOWN

(Worcester County)

CEMETERY

P. Redden

Rev. J. D. Long

E. Hearn

LINDEN

ST.

With the creation of the dollar, the tobacco warehouse gradually lost its purpose. By the late 1700s, the area first known as Steven's Ferry, then Meeting House Landing, and then Warehouse Landing received a new name: Newtown. Around 1780, Worcester County was properly surveyed and divided into districts; the river settlement lay in the Newtown district, so the name change presumably reflected its location. By 1809, nine lots had been sold, and by 1820, more than 150 people were living in the area in 28 dwellings and supporting seven or eight small businesses. This map, included in *Atlases and Early Maps of the Eastern Shore of Maryland 1877*, shows the growth and development along the river and the surrounding area that followed the boom in lumber production and shipbuilding. At the time the map was produced, Newtown's population was 1,500. The dilapidated tobacco warehouse, once the center of commerce along the riverbank, was razed in 1819.

In 1867, Newtown received its first charter from the Maryland legislature, along with authorization to incorporate. In 1878, citizens decided to change the name of their town to Pocomoke City and 10 years later elected Dr. Isaac Costen as their first mayor. Costen was born in neighboring Somerset County in 1832. He completed his medical studies at Penn Medical College in Philadelphia in 1857 and practiced for many years as a doctor while serving in Maryland government. He was a member of the Democratic State Central Committee for 15 years and was elected to the Maryland legislature in 1881. Settling in Newtown in the 1860s, Costen married Olivia Adams of Somerset County in 1866. (Courtesy of the Costen House Collection.)

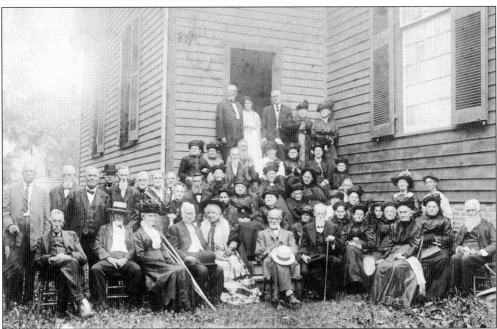

Dr. Costen gathers with fellow Pitts Creek Presbyterian Church members in 1910. Costen (fifth row, left) served the church as a trustee for many years and continued as clerk of sessions even after advancing age robbed him of his eyesight. His wife, Olivia, is third from the left in the first row. (Courtesy of the Costen House Collection.)

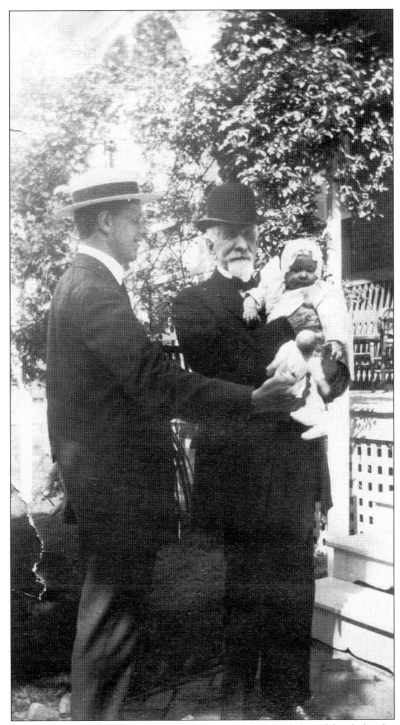

Dr. Isaac Costen is pictured with his cousin Courtney Hall (right) and his baby daughter May Elizabeth in 1914. Well loved and respected in the community, Costen has long been considered one of the town's founding fathers. He died on April 1, 1931, just a few months shy of his 99th birthday. (Courtesy of the Costen House Collection.)

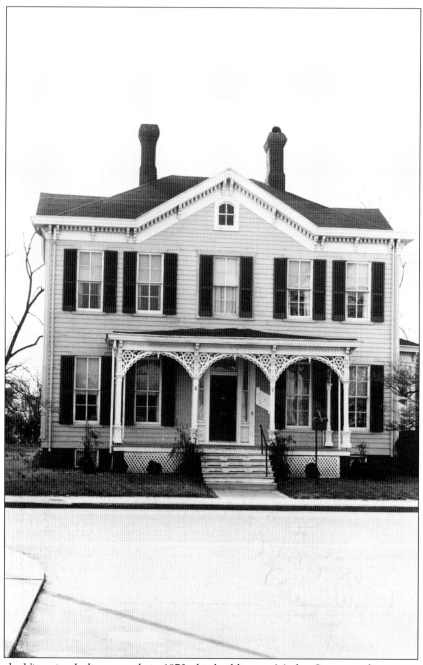

Built in the Victorian Italianate style in 1870, this building on Market Street was home to members of the Costen family until the 1970s. The couple had seven children: Rose, Eleanor, William, Addie, Mary, Olivia, and Elizabeth. Dr. Costen's medical office was also located here. The residence, featuring the side bay window, symmetrical shape, and fancy brackets and cornices associated with Italianate architecture, stands today as a museum offering a precious glimpse into Pocomoke City history. Dr. Costen served a two-year term as mayor and was reelected to additional terms as Pocomoke City experienced rapid growth following the arrival of the Pennsylvania Railroad. (Courtesy of the Costen House Collection.)

Two

GETTING DOWN
TO BUSINESS

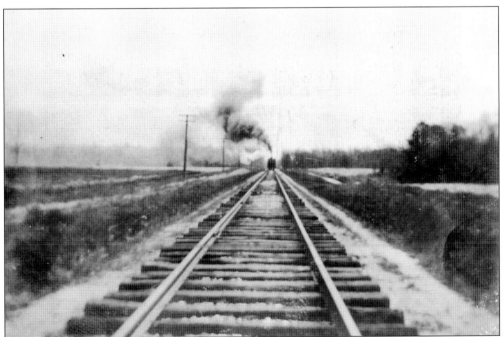

A railroad bridge was constructed over the Pocomoke River in 1880. By 1884, the New York, Philadelphia, and Norfolk Railroad had extended the rail line to Cape Charles, Virginia, and offered many new options for moving people and goods between Philadelphia and Norfolk. Pocomoke City had been linked to Baltimore by the Chesapeake Bay for many years, but the railroad bridge provided more accessibility to the town; thus, commerce flourished. By 1882, a daily train was running from Pocomoke City to Philadelphia. Here a train approaches town from the north before reaching the bridge crossing. (Courtesy of the Wigglesworth family.)

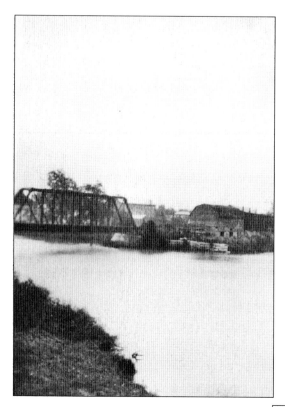

This photograph shows the railroad bridge spanning the Pocomoke River. After traveling the 62 miles from Pocomoke City to Cape Charles, Virginia, train cars crossed the Chesapeake Bay on barges and connected to other rail lines. These floating barges were reportedly designed by Alexander Cassatt, a railroad pioneer who served as president of the Pennsylvania Railroad from 1899 to 1906. Timber, seafood, and farm products could be transported to large cities, and hard-to-find goods could be delivered to the small towns on the Eastern Shore. (Courtesy of the Wigglesworth family.)

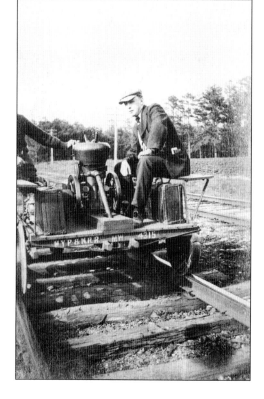

The railroad did more than move people and products through Pocomoke City; it offered employment opportunities. Here Clarence O. Huffman sits on what appears to be a hand car on the Pocomoke City tracks. Note the initials visible on the car: NYP&NRR (New York, Pennsylvania, and Norfolk Railroad). (Courtesy of the Wigglesworth family.)

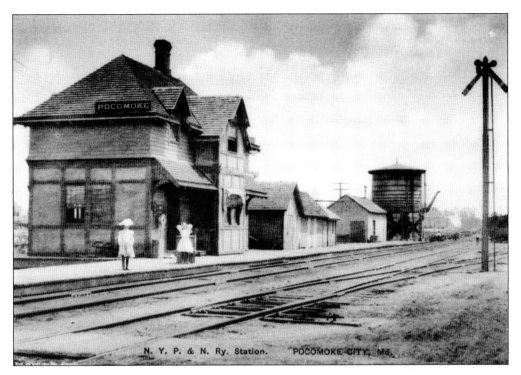

The original Pocomoke City railroad station consisted of a wooden depot until a modern brick building was completed in 1912. The two-story section in the front, clearly visible below, served as the passenger station. These photographs were taken around 1900. (Courtesy of the Wigglesworth family.)

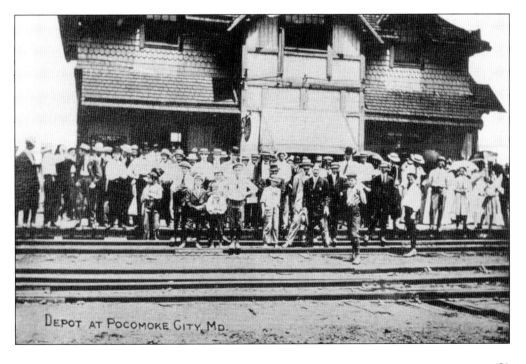

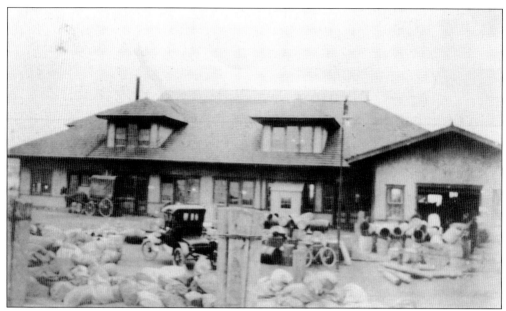

This early-1900s photograph depicts the freight station at the Pocomoke City depot. A horse and cart sit near the entrance, while an early automobile and bicycle appear in the foreground, surrounded by bundles awaiting shipment. (Courtesy of the Wigglesworth family.)

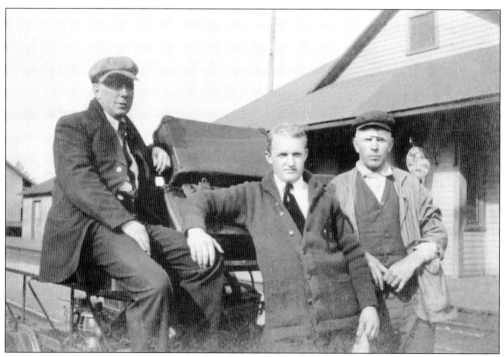

Clarence Huffman (left) perches on a rail car at the Pocomoke City depot in 1910. The other gentlemen are not identified. (Courtesy of the Wigglesworth family.)

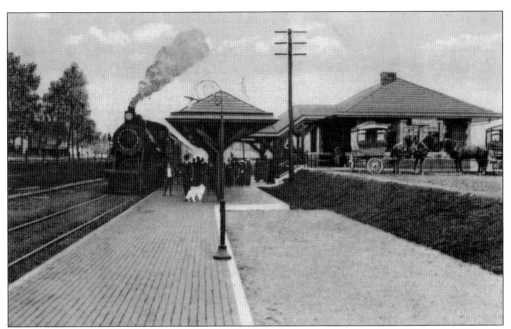

The old wooden depot was replaced by this modern train station in 1912. It remained in use until passenger train service was discontinued in the 1960s. A fire in 1989 nearly destroyed the building, but state and federal grants enabled the community to restore it. The structure survives today as a rental space available for meetings and special occasions. (Courtesy of the Wigglesworth family.)

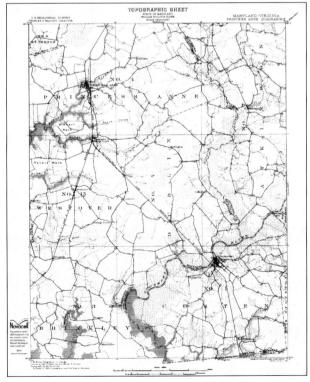

The New York, Pennsylvania, and Norfolk line and the development clustered on the banks of the Pocomoke River are clearly illustrated in this 1900 topographic map. By this time, 2,000 people were living and working in Pocomoke City, patronizing more than 35 shops, 3 carriage makers, 5 blacksmiths, and 3 gristmills. This map, the result of a U.S. geological survey completed by H. M. Wilson, was published in 1901. (Courtesy of Novacell Technologies, www. novacell.com.)

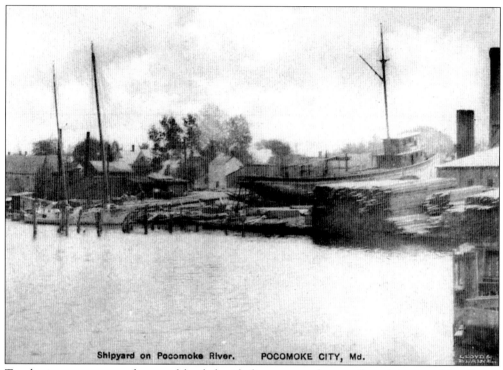

Shipyard on Pocomoke River. POCOMOKE CITY, Md.

Two businessmen spotted a vessel loaded with fine cypress fence rails arriving at a New Jersey port in 1844. When they discovered Newtown was the origin of the wood, they rushed to the site. The businessmen, John Ashcraft and Ezra Riley, established a steam sawmill near the Pocomoke River and helped usher in a golden age of shipbuilding. Three shipyards were opened along the river: Captain Clarke's, Hall and Brothers, and E. James Tull's. Boatbuilding concerns employed more than 100 men and used the plentiful local supply of cypress and pine. This unidentified shipyard was once located in Pocomoke City. Notice the large piles of lumber in the foreground and what appear to be two vessels under construction. (Courtesy of the Preston and Mary Marshall estate.)

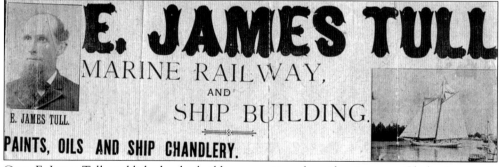

Capt. E. James Tull established a shipbuilding operation along the river near Clarke Avenue. It produced more than 200 vessels in 35 years, including yachts, barges, launches, and steamships. At the time of his death in the 1920s, railroad growth had decreased the demand for sailing vessels, prompting the shipyard to close. A respected member of the community, Tull served three terms as mayor. (Courtesy of the Costen House Collection.)

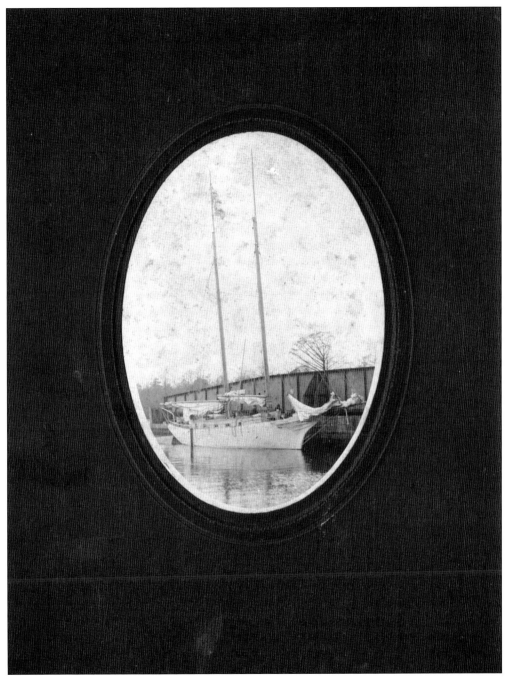

An unidentified vessel sits in front of the railroad bridge on the Pocomoke River. (Courtesy of the Delmarva Discovery Center.)

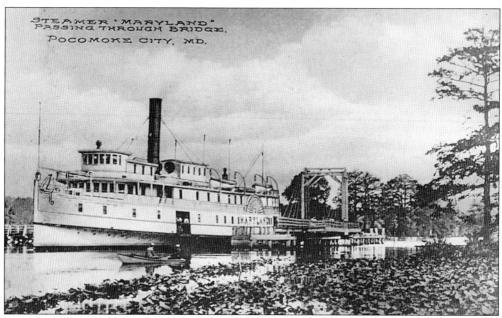

Before the railroad bridge's 1880 construction, the above bridge spanned the river. The caption for the above image reads, "Steamer 'Maryland' Passing Through Bridge." The below photograph, taken during the time of the railroad bridge, depicts "Steamer Passing Through NYP&N Draw Bridge, Pocomoke, MD." In early December 1890, the steamship *Maryland* lost her captain and two crew members in a fierce storm that raked the Atlantic coast. A *New York Times* article dated December 7, 1890, said of the *Maryland*, "The wheelhouse was smashed, as was also the chartroom. All her boats except one were carried away. All the nautical instruments were lost." (Courtesy of the Costen House Collection.)

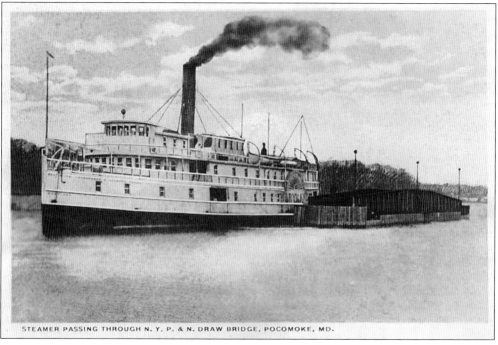

STEAMER PASSING THROUGH N. Y. P. & N. DRAW BRIDGE, POCOMOKE, MD.

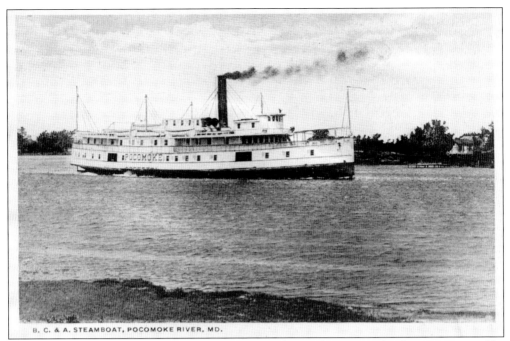

The steamboat *Pocomoke* rides the Pocomoke River during the 1890s. The ship was acquired by the Baltimore, Chesapeake, and Atlantic Railway Company in 1894. (Courtesy of the Costen House Collection.)

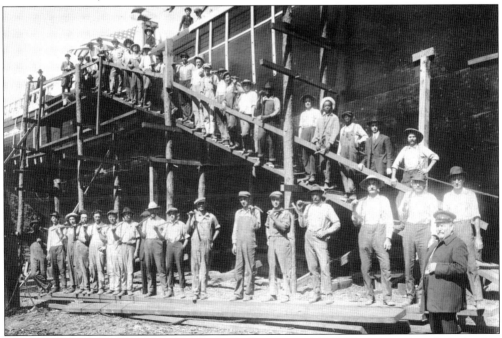

This photograph was taken at Tull's Marine Railway around 1915. Though unidentified, the ship may have been of some importance, since the workmen, displaying various hand tools, took time away from their tasks to pose for a photographer. The last ship built at the Pocomoke shipyards was the *Lillian Kerr*, christened in 1920. (Courtesy of Winnie Small.)

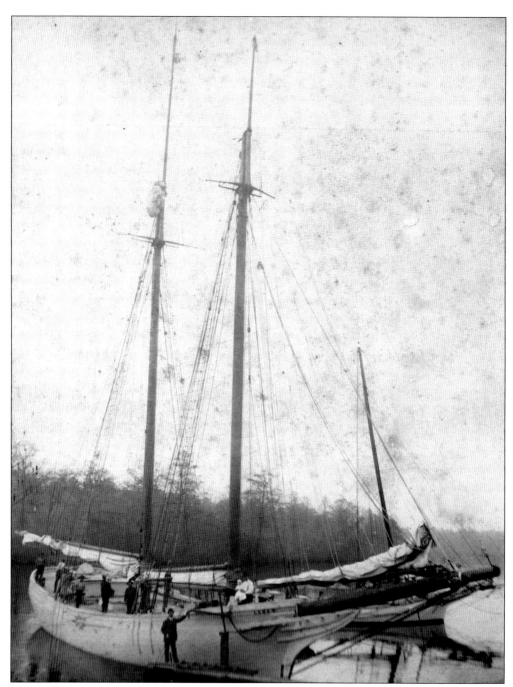

Jane Tull Hancock, Captain Tull's daughter, described the pictured ship: "The *Lena D* was built in 1910 by my father in Pocomoke City, Maryland. She measured 76 feet in length, 25.2 feet in beam and 5.4 in depth. She was registered at New York." (Courtesy of the Delmarva Discovery Center.)

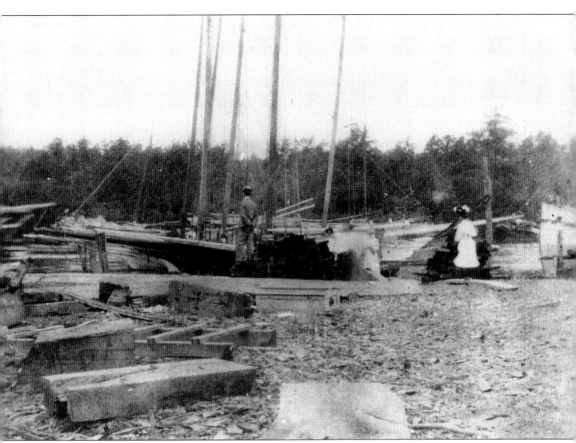

Work progresses at one of the Pocomoke City shipyards in the early 1900s. The debris in the foreground was used in ship launching. (Courtesy of the Wigglesworth family.)

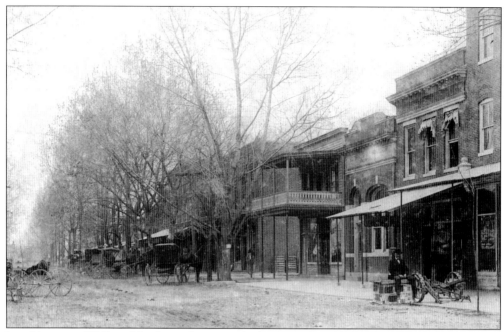

Local historian William Matthews claims it is fairly easy to date this view of Market Street, which looks north toward the river. He states, "This image is *c.* 1900 or earlier; by 1912 these trees were no longer present on Market Street." (Courtesy of the Costen House Collection.)

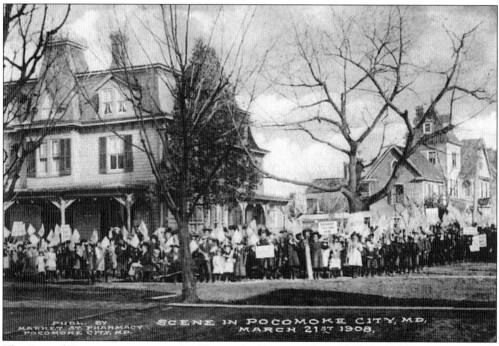

The Sons of Temperance organized in Pocomoke City as early as 1847. By 1865, spirits were only available at drugstores for medicinal use. Here a group of citizens gathers on Second Street in 1908, rallying for the town to remain dry. A child in the foreground hoists a sign reading "Fathers, Vote for Me." (Courtesy of the Wigglesworth family.)

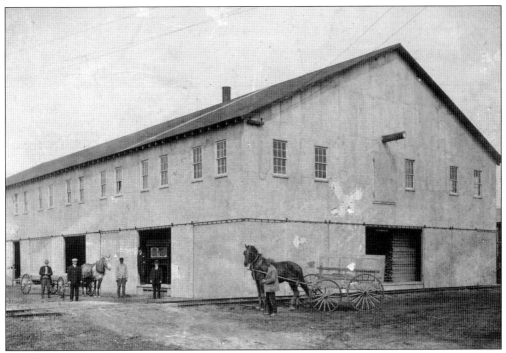

The Ashburn, Child, and King lumber warehouse is stocked with boards and carts ready to be loaded for delivery in 1910. This lumber business, though in a different location, is still in existence in Pocomoke City and is owned and operated by Ashburn's great-grandson. (Courtesy of the Costen House Collection.)

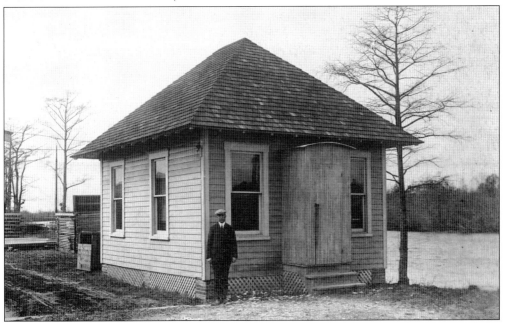

Quince Ashburn stands near the office at the Ashburn, Child, and King Lumberyard in 1910. The growth of industry and population in Pocomoke City was a boon to lumber production. Local mills flourished as a result of the great demand for cypress and pine. (Courtesy of Norma Miles.)

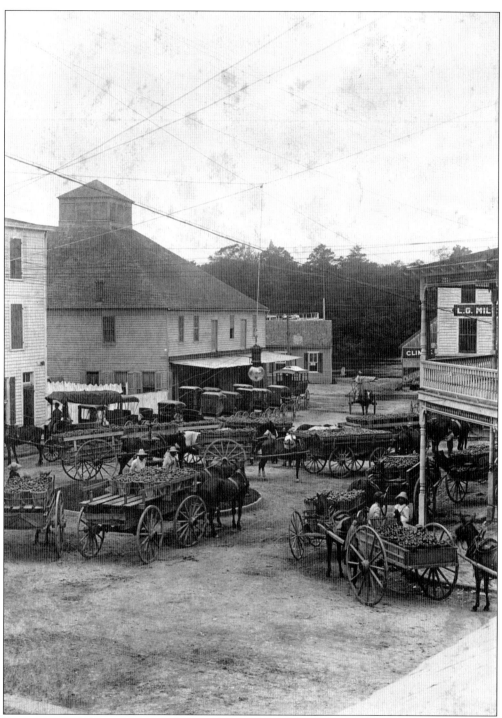

Processing and shipping Pocomoke City's abundant agricultural products was big business for the town in the early 1900s. This photograph shows a view of Market Street with wagonloads of tomatoes ready for market. A hanging streetlight is visible in the center, and a glimpse of the river is seen in the center background. (Courtesy of the Costen House Collection.)

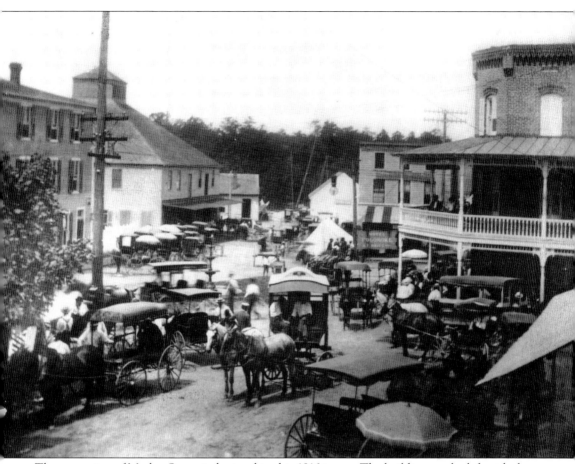

The same view of Market Street is depicted in this 1916 image. The building on the left with the cupola has been identified as a livery stable. The two-story building on the right with the fine second-story porch is the Hotel Pocomoke, bearing the sign "A. T. White, Prop." A flour mill can be seen just past the hotel. (Courtesy of the Preston and Mary Marshall estate.)

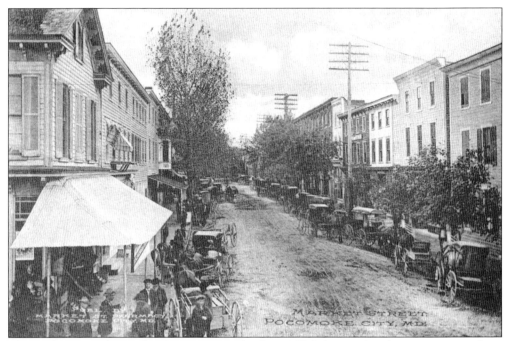

This early postcard, "Market Street Pocomoke City, MD," shows a bustling street scene from the early 1900s. The writing in the lower left corner credits production to the Market Street Pharmacy. The card offers a rare view of the street south of the Pocomoke River. (Courtesy of the Costen House Collection.)

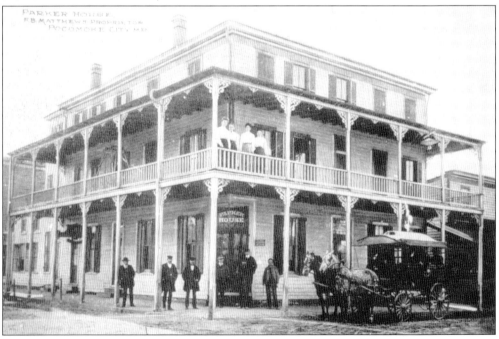

The Parker House, pictured here in 1902, offered fine accommodations on the corner of Willow Street and Clarke Avenue. The carriage in front of the building, one of the town's earliest taxis, was used to transport guests to and from the railroad station. (Courtesy of the Wigglesworth family.)

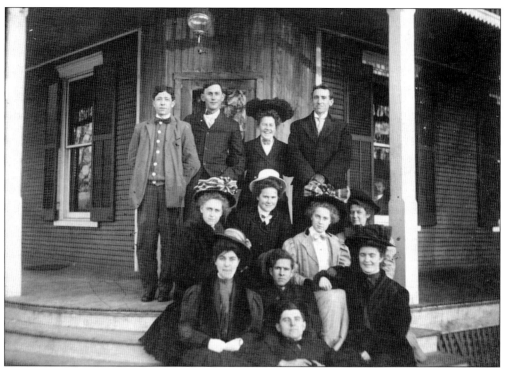

Patrons pose on the front steps of the Parker House, near the lobby entrance, in 1911. All are unidentified except Katherine Pilchard (second row, left) and Jennie Pilchard (second row, third from left). (Courtesy of the Costen House Collection.)

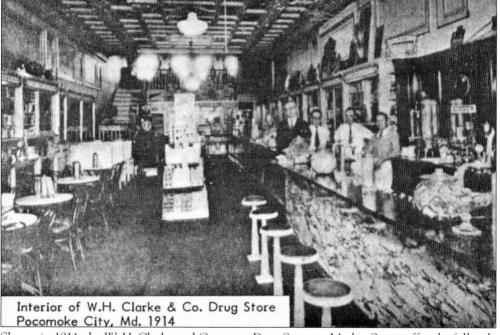

Interior of W.H. Clarke & Co. Drug Store
Pocomoke City, Md. 1914

Shown in 1914, the W. H. Clarke and Company Drug Store on Market Street offered a full soda fountain and sundries. (Courtesy of the Costen House Collection.)

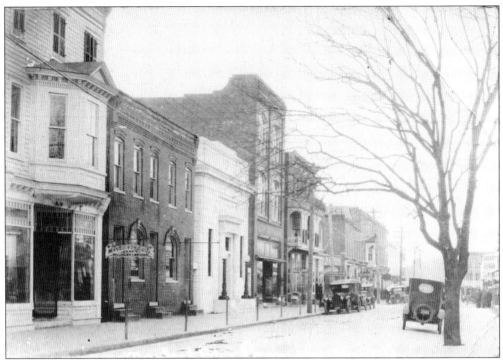

This view looks down Market Street toward the river in 1920. (Courtesy of the Costen House Collection.)

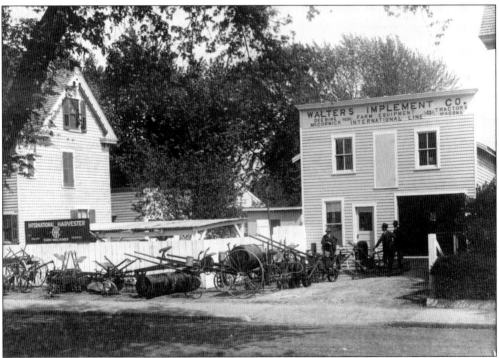

Tractors, wagons, and other farming equipment were sold and serviced at the Walters Implement Company on Fourth Street, seen here in 1920. (Courtesy of the Costen House Collection.)

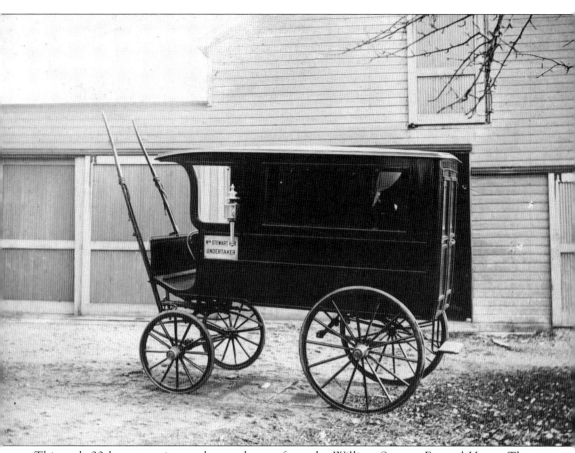

This early-20th-century image shows a hearse from the William Stewart Funeral Home. The building has been identified as the Fuller Walters property on Fourth Street. (Courtesy of the Costen House Collection.)

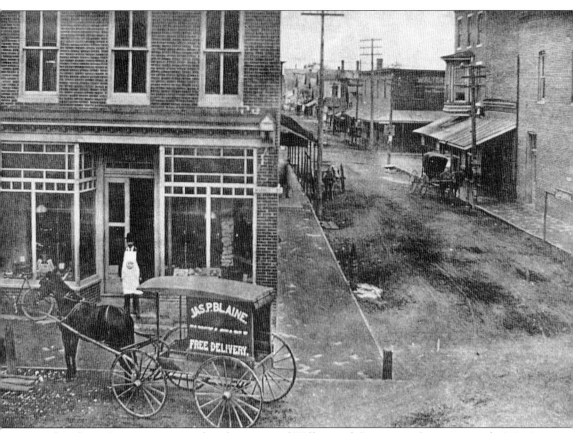

The Blaine Grocery is pictured at the corner of Willow and Commerce Streets around 1910. At this time, the streets remained unpaved, and Clarke Avenue was still called Commerce Street. (Courtesy of the Costen House Collection.)

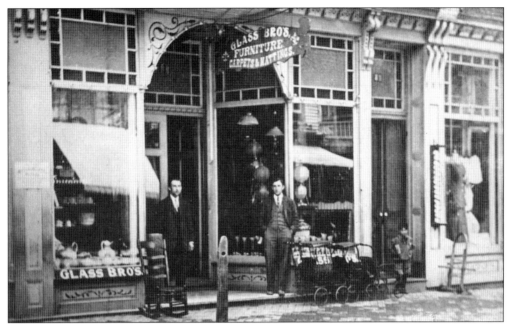

All the fine homes being built in Pocomoke City in the early 1900s cried out for fine furnishings, and Glass Brothers Carpet and Furniture provided just that. The neat beveled windows of the store, located on the west side of Market Street, reveal a large selection of lamps, china, and other products. This photograph is dated 1916. (Courtesy of the Costen House Collection.)

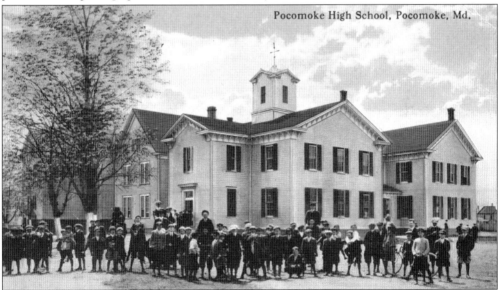

The Maryland General Assembly passed a free school bill in 1865, and the original town high school building (pictured) was erected on Walnut Street in 1867. In *History of Pocomoke City, Formerly Newtown*, Rev. James Murray wrote, "Its dimensions were fifty six by forty feet. It is two stories high with two vestibules fourteen by twenty feet, containing in all six school rooms and two vestibules. This high school building has been pronounced by the Superintendent of the Public Schools of Maryland to be the finest building of its kind on the Eastern Shore of Maryland." (Courtesy of the Costen House Collection.)

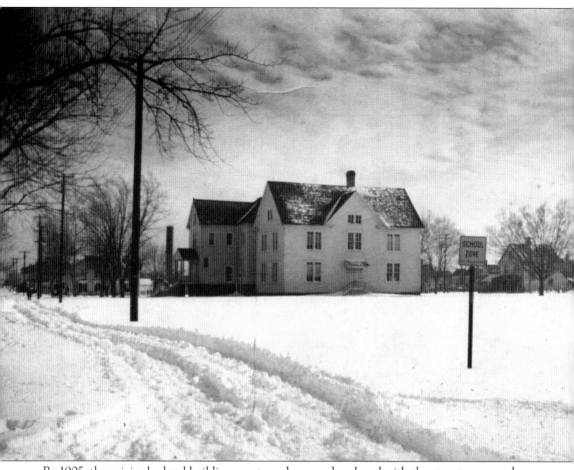

By 1905, the original school building was torn down and replaced with the structures seen here. (Courtesy of the Costen House Collection.)

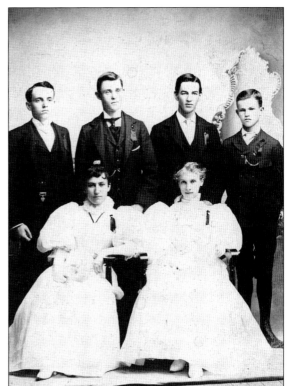

These photographs feature the Pocomoke High School class of 1896. Shown at right at their graduation are the following, from left to right: (first row) Marie Jones and Cleore Bonneville; (second row) Howard Clogg, Norman Sartorius, Frank Stevenson, and Clarke Fontaine. The group is featured below, in the same order, at a class reunion in 1906. (Courtesy of the Costen House Collection.)

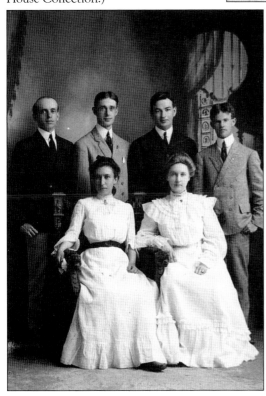

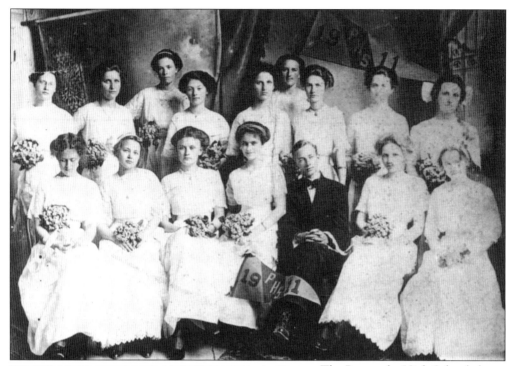

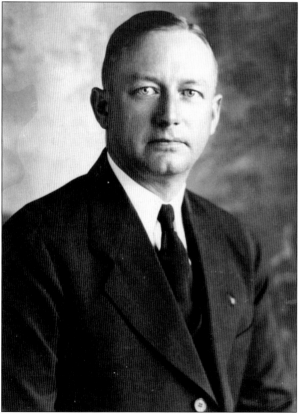

The Pocomoke High School class of 1911 is pictured above. The lone gentleman, seated in the first row, has been identified as Godfrey Child (1894–1977). Child, pictured bat left, graduated from law school at the University of Maryland in 1917. A World War I veteran, he was instrumental in forming Pocomoke City's National Guard unit in 1923. He later served an eight-year term as Worcester County state's attorney and became the first Worcester County judge of the First Judicial Circuit of Maryland. (Courtesy of the Costen House Collection.)

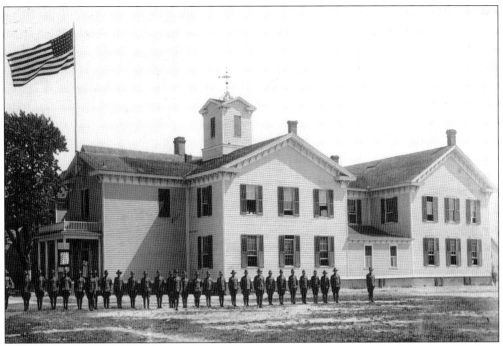

The military was brought in during World War I to protect Pocomoke City's bridges. While in town, the soldiers were housed at the Pocomoke High School. These images show the troops drilling on the school grounds in 1918. (Courtesy of the Costen House Collection.)

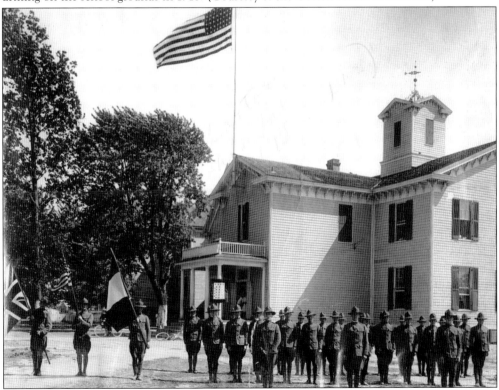

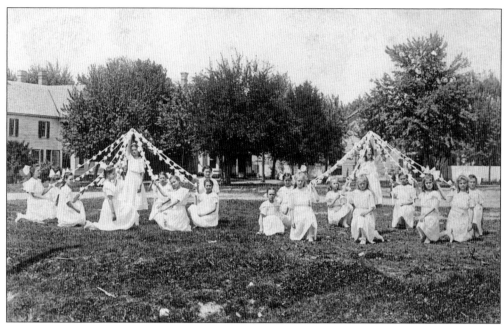

A May Day celebration, complete with two maypoles, occurs on the Pocomoke City school ground in the early 1900s. Observed on May 1 as a revival of life in early spring, May Day gave young people the opportunity to sing and dance, gather and distribute flowers, and show off their spring finery. (Courtesy of the Costen House Collection.)

Two of Pocomoke City's young ladies, Edna Ashburn (right) and Margaret Blades, frolic on Second Street in 1918. (Courtesy of the Costen House Collection.)

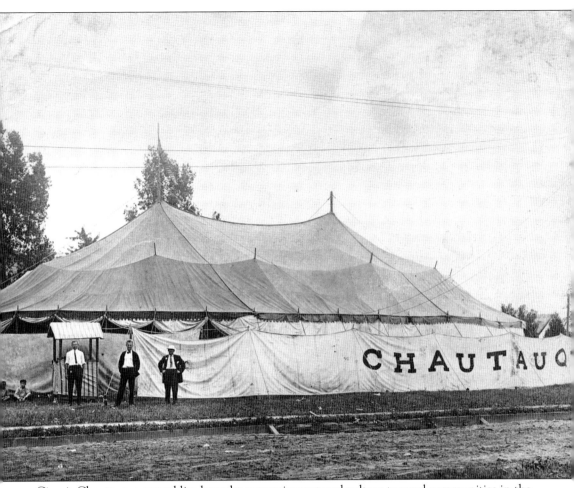

Circuit Chautauqua assemblies brought entertainment and culture to rural communities in the early 1900s. Lecturers, preachers, and entertainers appeared in tents that were pitched on well-drained fields near a town. The Chautauqua Movement, first organized in New York in 1874 by Methodist minister John Heyl Vincent and businessman Lewis Miller, remained popular in small towns until the advent of radio and movies made information and entertainment more readily available. When the Circuit Chautauqua traveled to Pocomoke City, the tent was set up on the school grounds at Fourth and Walnut Streets. (Courtesy of the Costen House Collection.)

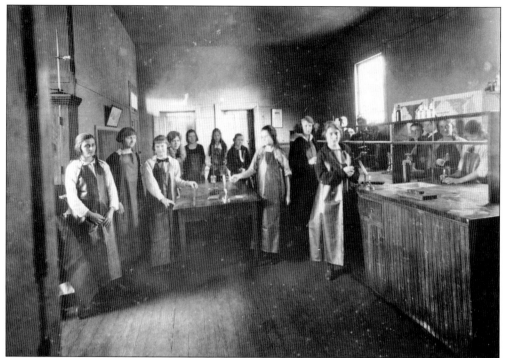

Members of the Pocomoke High School class of 1923 pose while wearing protective aprons in the school chemistry lab. (Courtesy of the Costen House Collection.)

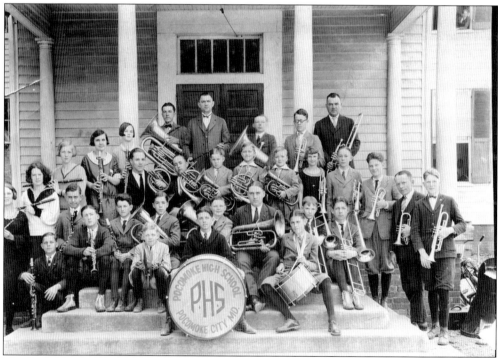

The Pocomoke High School band poses on the steps of the school on May 19, 1925. (Courtesy of the Costen House Collection.)

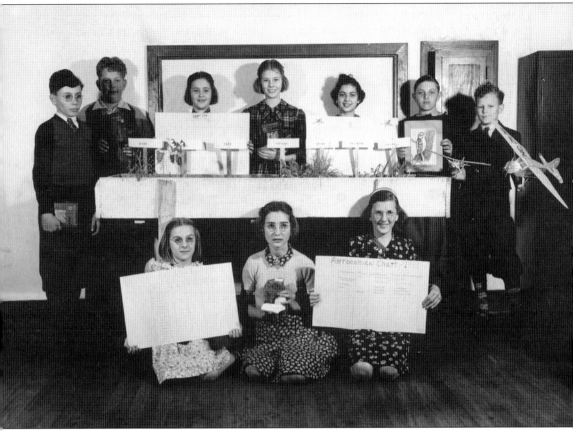

The seventh-grade science class poses with students' completed projects in 1939. Pictured from left to right are the following: (first row) Louise Watson, Pauline Wilson, and Irene Godwin; (second row) Ralph Denston, Ralph Lankford, Hortense Bunting, Virginia Matthews, Ruth Helig, Bill Small, and Franklin Wilkerson. (Courtesy of Winnie Small.)

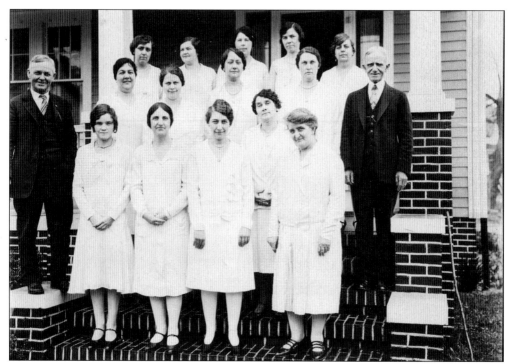

Pocomoke City has a rich history of supporting clubs, community organizations, and the arts. Here early townspeople participate in an Eastern Star gathering (above) and in a Christmas production. (Courtesy of the Costen House Collection.)

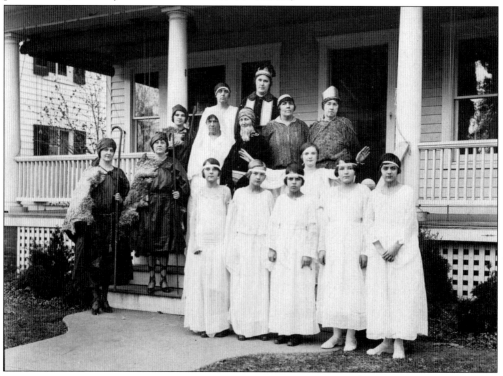

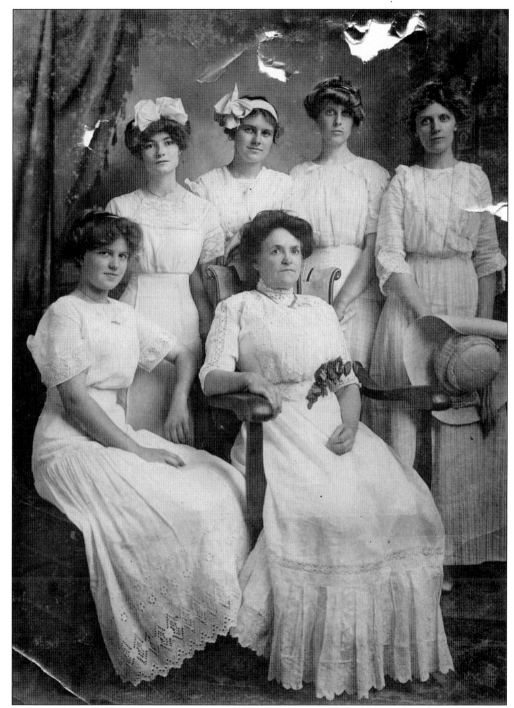

The faded writing on the back of this photograph reads, "Aunt from California Sketch, Pocomoke, August 29th, 1912." Coach Sidney Hall of New York is seated. The other ladies are, from left to right, Gertrude Blades, Sue Redden, Ruth Young, Julia Hall, and Peggy-Belle Hall. These are local ladies that performed in a production. The writing is from 1912 and is on the back of the photograph. (Courtesy of the Costen House Collection.)

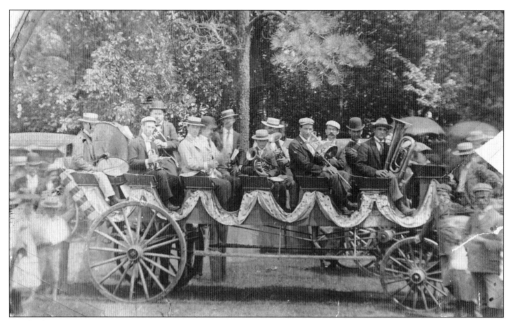

The Pocomoke Community Band is seen in the bandwagon sometime between 1895 and 1900. The gentlemen in this photograph are unidentified. (Courtesy of the Costen House Collection.)

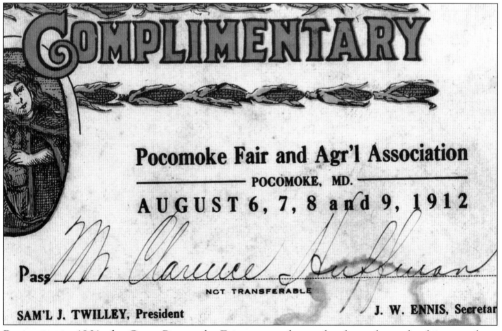

COMPLIMENTARY

Pocomoke Fair and Agr'l Association

POCOMOKE, MD.

AUGUST 6, 7, 8 and 9, 1912

Pass

NOT TRANSFERABLE

SAM'L J. TWILLEY, President J. W. ENNIS, Secretar

Beginning in 1901, the Great Pocomoke Fair attracted crowds of people to the fairgrounds at the corner of Second and Broad Streets every summer through 1930. Horse racing, side shows, and games of chance were featured attractions. Farm products such as produce and poultry and handiwork like quilting and canning were displayed and rewarded. This complimentary pass to the fair was given to Clarence Huffman by the Pocomoke Fair and Agricultural Association in 1912, saving him the general admission price of 25¢. (Courtesy of the Wigglesworth family.)

Pocomoke City's growing population led to the establishment of several churches in the late 1800s. Pitts Creek Presbyterian Church (pictured) was built on Market Street in 1844. The Market Street church joined the original Pitts Creek Presbyterian Church, later named Beaverdam Presbyterian Church, built five miles south of town on Pitts Creek. According to Murray's *History of Pocomoke City, Formerly Newtown*, the church was "built of the best material, and in workmanlike manner. It has good proportions and is kept in the neatest style." (Courtesy of the Costen House Collection.)

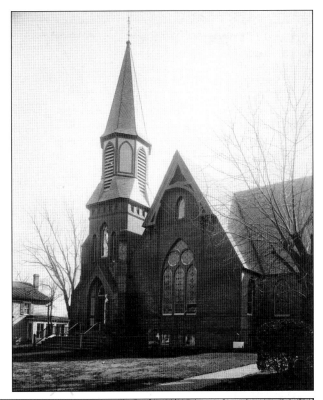

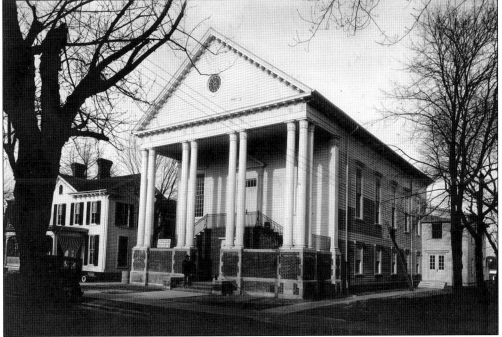

Bethany Methodist Church was erected on Church Street (Third Street) in 1832. Some 50 years later, the congregation relocated to 203 Market Street, seen here. (Courtesy of the Costen House Collection.)

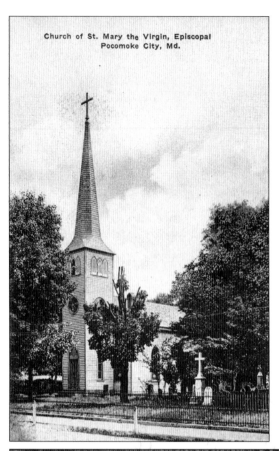

Church of St. Mary the Virgin, Episcopal
Pocomoke City, Md.

St. Mary the Virgin Episcopal Church was built on Church Street in 1845. Records from 1888 indicate a congregation of "85 communicants and a Sunday School with 65 members." (Courtesy of the Costen House Collection.)

In 1854, the First Baptist Church was constructed on the corner of Fourth and Market Streets. Reverend Murray wrote, "The church is built of good material and by one of the best workmen in the country, Mr. Isaac Marshall, deceased, of Somerset County, Maryland." The altar features a sign reading "Our Jubilee" in this 1910 image. (Courtesy of the Wigglesworth family.)

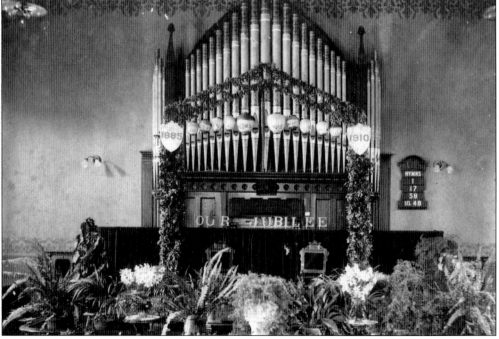

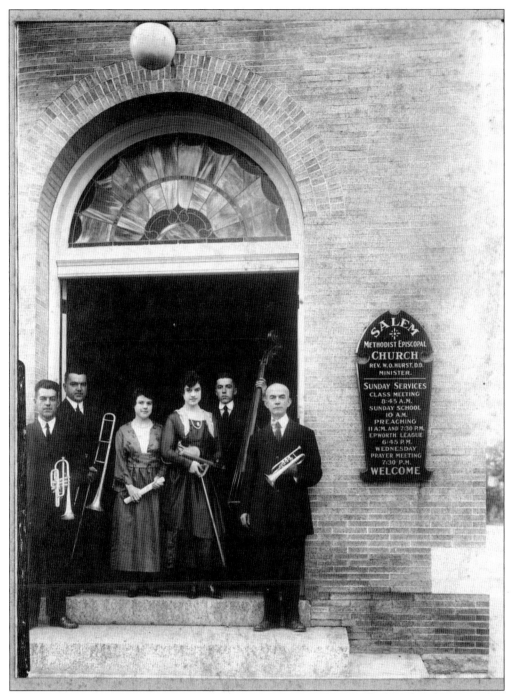

Erected at the corner of Second and Walnut Streets in 1808, Salem Methodist Church was "neither lathed nor plastered for thirty years. At first, its benches were thick planks laid on blocks of wood but in process of time it had benches with backs to lean against," according to Rev. James Murray in his book *History of Pocomoke City, Formerly Newtown*. A new church building was completed in 1905. Members of the orchestra gather on the steps of the new Salem Church in the early 1900s. (Courtesy the Costen House Collection.)

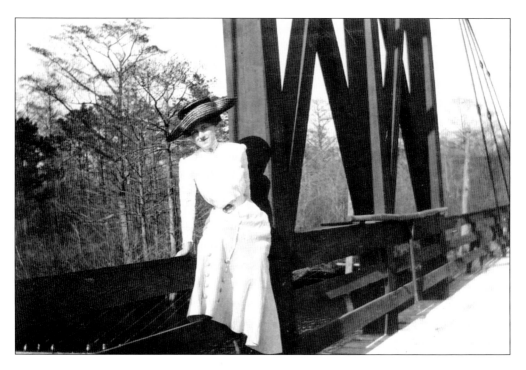

Etta Eck Huffman of Pocomoke City (above) perches saucily on the old wooden drawbridge about 1910. This span was built in 1865 at the site of the original ferry crossing. The Maryland State Roads Commission was created in 1908 to oversee construction, maintenance, and improvement of roads and highways, and in 1920, a modern drawbridge began to take shape over the Pocomoke River. The image below depicts the new bridge, completed in 1921, with the keeper's tower on the right. (Courtesy of the Wigglesworth family.)

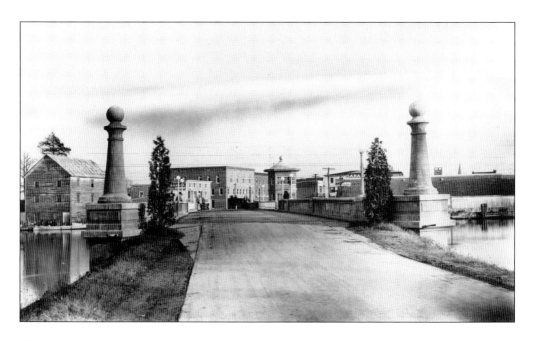

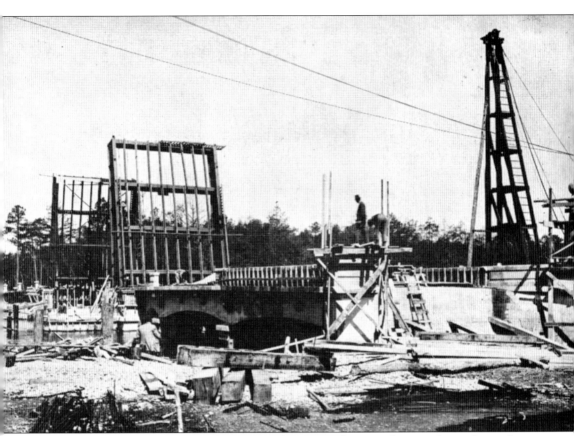

The Pocomoke River drawbridge is being erected in 1920. This rare photograph was featured in the 1921 Pocomoke High School yearbook, *The Chat*. Adjacent to the image was an advertisement crediting construction of the bridge to the McLean Contracting Company of Baltimore. (Courtesy of Winnie Small.)

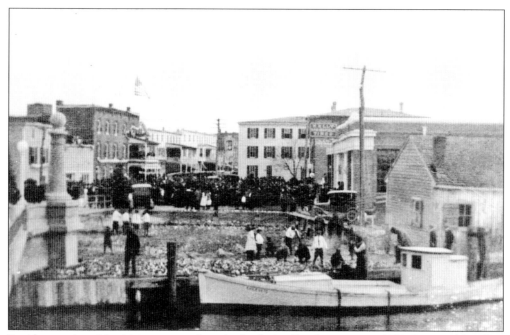

Residents enjoyed festivities surrounding the bridge's official opening in 1921. Presumably taken from the bridge keeper's tower, the above photograph shows well-dressed people ambling along the riverbank. On the right, behind the shanty in the foreground, is the Duncan Brothers Automobile Sales and Service building. The three-story building with the striped awnings is the Ford House hotel. Across the street, an American flag waves above the Hotel Pocomoke. The below photograph, taken from the opposite vantage point, clearly shows the keeper's tower. A crowd of people and automobiles awaits an opportunity to cross the new bridge for the first time. (Courtesy of the Preston and Mary Marshall estate.)

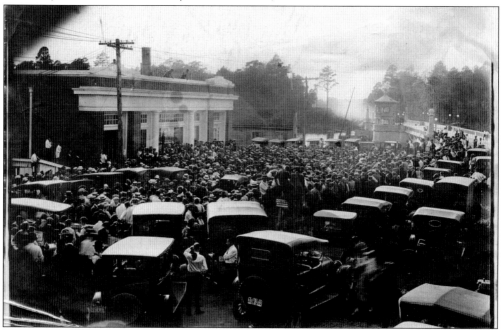

Three

CONFLAGRATION

The early 1900s was a time of great growth in Pocomoke City. With local enterprises booming and families flocking to the area to take advantage of job opportunities, things were looking up on all fronts. On April 17, 1922, the idyll enjoyed by the residents of Pocomoke City was altered forever by flames. In less than four hours on that fateful Monday afternoon, 250 people were left homeless, 81 buildings of every description were destroyed, and the face of the city was changed forever. Shown here is some of the devastation on Front Street and the north end of Market Street. The clock clings to the facade of Citizens Nation Bank, the only building in the Market Street business section to survive. The steeple of Pitts Creek Presbyterian Church is visible in the right background. (Courtesy of the Wigglesworth family.)

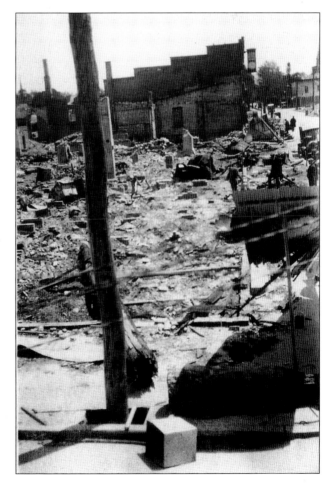

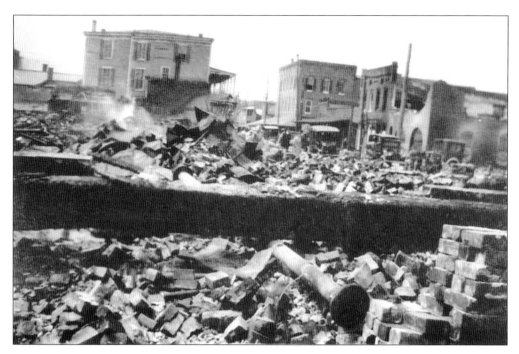

The fire started in a Market Street stable owned by Frank Wilson. The April 25, 1922, edition of the *Marylander and Herald*, a newspaper published in nearby Princess Anne, recounted the following: "Some residents say a passerby threw a lighted cigar near the door of the stable and it was blown by the high wind along the floor until it reached a pile of hay. Others say a small pile of rubbish was burning on the street and that this was blown into the stable." These images reveal some of the damage in the Market Street business section. Every doctor's office and drugstore burned, leaving Pocomoke City without medical supplies. Many power poles were also destroyed by the fire, leaving the town without lights for several days. (Courtesy of the Wigglesworth family.)

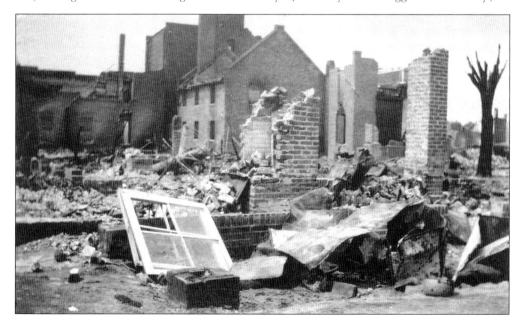

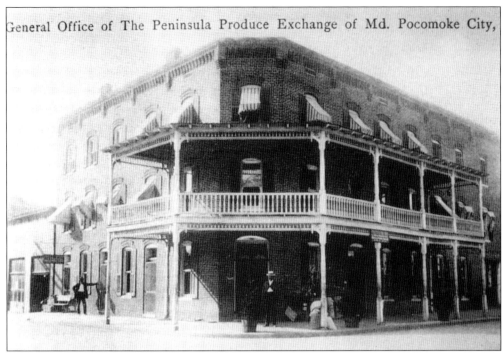

General Office of The Peninsula Produce Exchange of Md. Pocomoke City,

"The Peninsula Produce Exchange, a three story brick building on the corner of Market and Front Streets, prevented the spread of the fire in this section," according to the *Marylander and Herald*. The Exchange is pictured here in the early 1900s. Fire departments arrived from Snow Hill, Crisfield, Salisbury, Princess Anne, Berlin, and Ocean City, Maryland, as well as Laurel and Seaford, Delaware, to help contain the blaze. (Courtesy of the Wigglesworth family.)

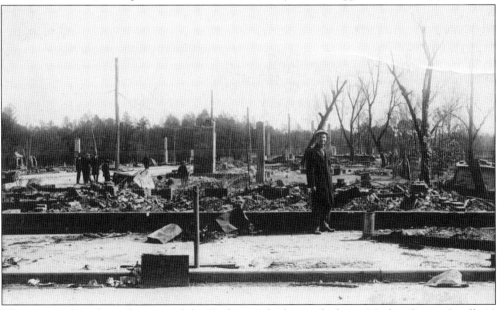

This view, taken from the area of the Exchange, looks south down Market Street. In all, 10 business and residential blocks were affected, and property estimated at $1.5 million was destroyed. (Courtesy of the Costen House Collection.)

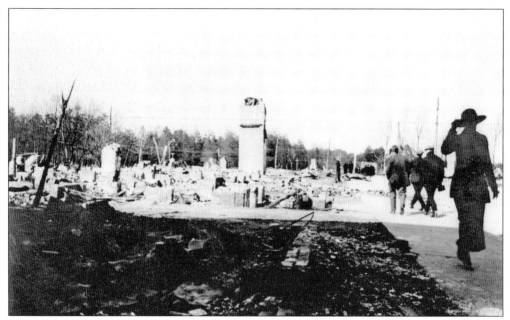

Front Street was a prime residential area not far from the Pocomoke River. Every home on the street was destroyed by the fast-moving flames. Here dazed citizens survey the damage. (Courtesy of the Wigglesworth family.)

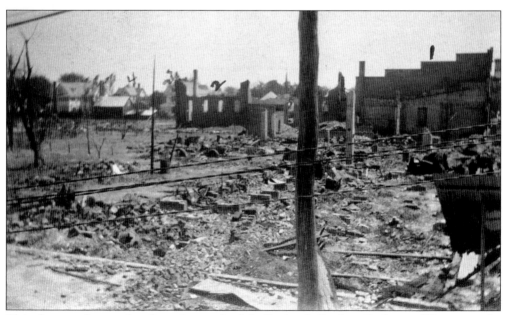

This photograph was taken from the porch of the Peninsula Produce Exchange. Writing on the reverse identifies the subject as "ruins on the north end of Market Street. The X mark shows where the Electric and Ice Company safe was. They opened it afterward but most everything was burned." (Courtesy of Winnie Small.)

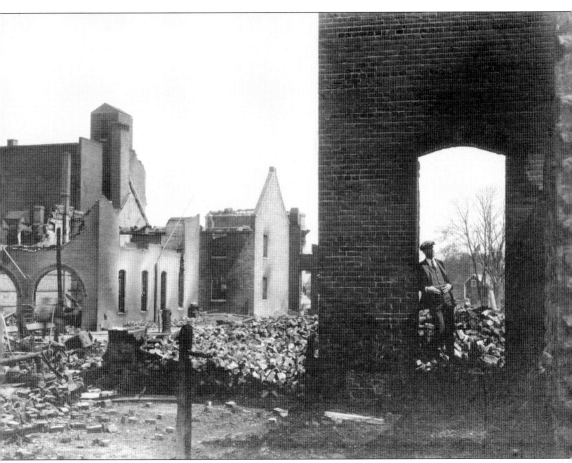

Willow Street is depicted after the fire. Prior to the 1922 blaze, Pocomoke City had experienced two other fires that affected the same part of the town. In 1888, some 79 buildings were lost in the area of Front and Market Streets when a fire started in a doctor's downtown residence. Fought mostly by volunteers, possibly manning a hand pumper and assisting with a bucket brigade, the 1888 blaze prompted town commissioners to charter and organize a volunteer fire company. W. H. Davis was appointed chief. A fire engine steamer was acquired by the company, and a firehouse was established on Willow Street. In July 1892, flames originating on Willow Street in a store occupied by J. Bonneville followed the same path of destruction, resulting in the loss of 69 buildings. The history of the Pocomoke City Fire Department is incomplete, as the 1922 fire destroyed the Willow Street firehouse along with all previous records. (Courtesy of the Costen House Collection.)

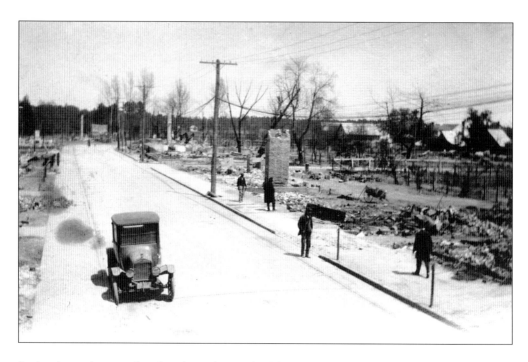

In the above photograph, taken from the porch of the Peninsula Produce Exchange, townspeople survey the remains of business and residential lots on Market and Front Streets. Some of the town's finest homes were destroyed, leaving behind only stone steps and brick chimneys (below). The *Worcester Democrat*, Pocomoke City's local newspaper, stated the following in its April 22 edition: "It is no easy task to take pen in hand and attempt to describe minutely the successive steps by which one's home town has been changed over night from a place of charm and beauty to masses of charred and smoldering ruins." (Courtesy of Winnie Small.)

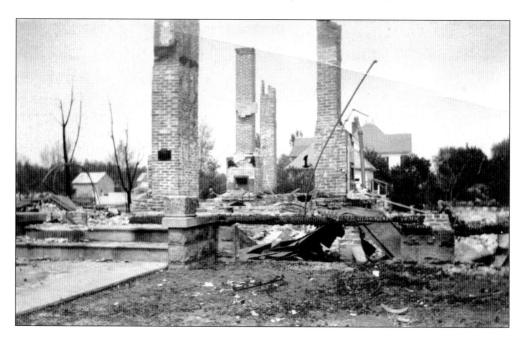

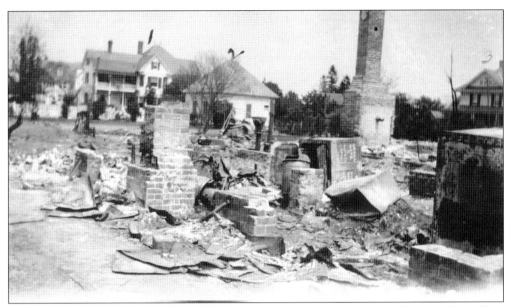

The two safes in the foreground are all that remained of the Crockett and Crockett law offices on Market Street. The Western Union telegraph office and the post office were also destroyed in the fire. (Courtesy of Winnie Small.)

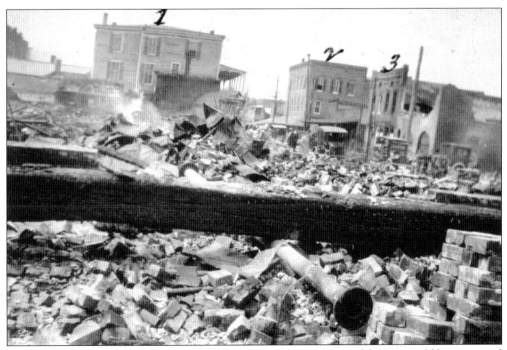

According to the *Worcester Democrat*, "The scene in the very heart of the city could be compared without exaggeration to the scenes in the war-devastated region of France and Belgium after the invasion of the German troops." The building still standing on the left is the Parker House. (Courtesy of Winnie Small.)

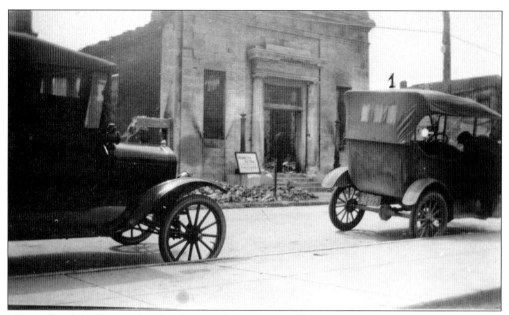

The walls of the Pocomoke City National Bank on Market Street remained after the fire, but the roof was destroyed. Intense heat caused pieces of the building's marble facade to crumble and fall. The bank's sign can be seen propped in front of the building with bricks and other debris heaped beneath it. (Courtesy of Winnie Small.)

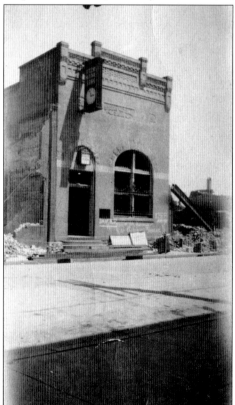

Citizens National Bank, a Market Street fixture since 1902, was one of the few buildings in the business section to survive the blaze. The clock on the front of the building stopped just before 3:00 on the afternoon of the fire, when the electric wires that powered it were burned. The burglar alarm reportedly sounded for over an hour until its power source was destroyed. (Courtesy of Winnie Small.)

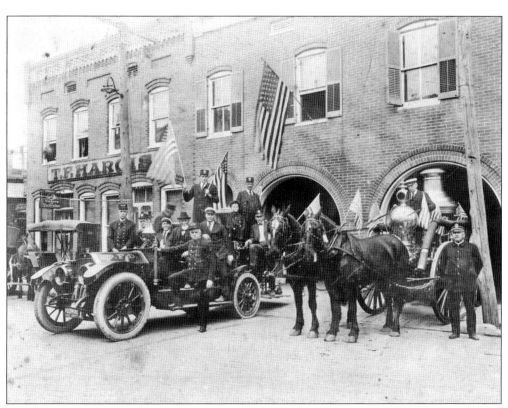

The Pocomoke City Volunteer Fire Company poses at the Willow Street firehouse in the early 1920s. Shown above from left to right are James Dryden, Herman Ellis, Clarence Dryden, Jacob Stevenson, Chief Andrew Pickens, Vernon Stevenson, John Causey, Gus Bowling, Bill Powell, Calvin Townsend, and W. A. Stroud. A horse-drawn Clapp and Jones steamer is visible on the right. The distinctive arches of the burned-out firehouse are visible in the center of the photograph at right. (Courtesy of George Henderson.)

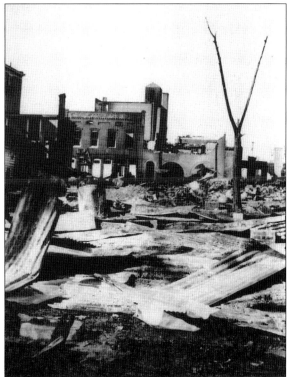

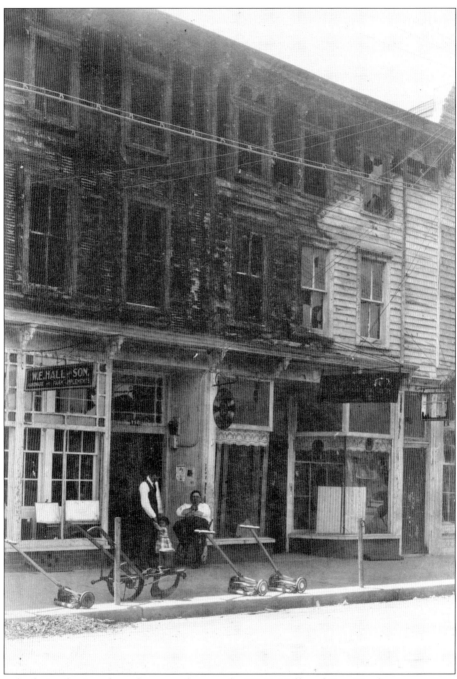

Though obviously singed on the second story, the W. E. Hall and Son Hardware store appears to be open for business. An unidentified man and little girl stand in the doorway of the store while Granville "Oolie" Hall sits and surveys the mowers and implements offered for sale. (Oolie would later gain fame as the world's heaviest man, weighing more than 700 pounds at the time of his death in 1938.) In as little as 24 hours after the devastating downtown fire, Pocomoke City citizens reportedly gathered at a meeting in a local church to discuss plans for rebuilding. (Courtesy of the Costen House Collection.)

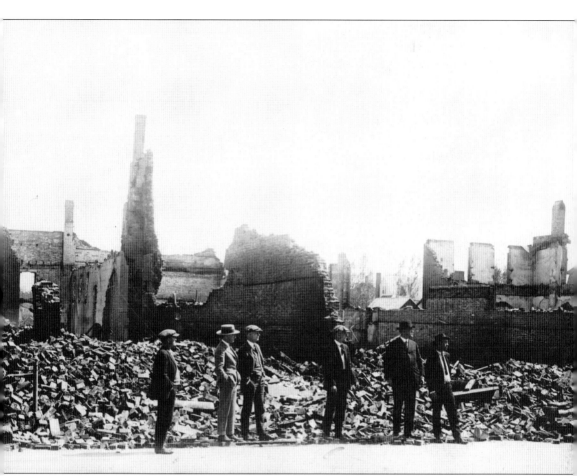

In the days following the fire, Mayor E. James Tull assessed the grave situation and asked Maryland governor Albert C. Ritchie to send the National Guard to the area to preserve order. The *Worcester Democrat* reported, "We have failed to hear of one single incident throughout the entire course of the disaster which would cause the blush of shame to mantle the cheek of those who take pride in calling Pocomoke City their home. The majesty of the law, a sense of security, and perfect order were conspicuous and preeminent throughout the day and night." Here citizens survey the damage in the Willow Street area. (Courtesy of the Costen House Collection.)

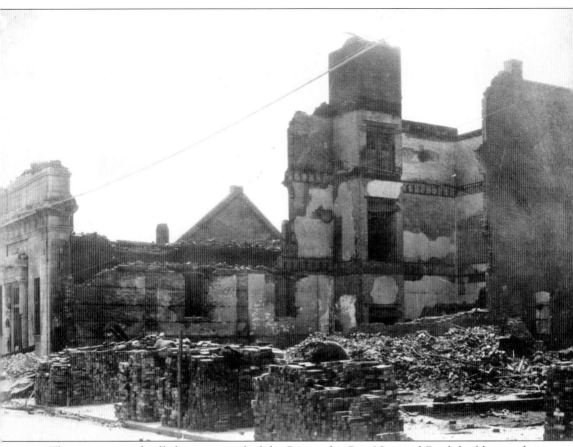

This image reveals all that remained of the Pocomoke City National Bank building and its neighboring structures on north Market Street. Neat piles of bricks in the foreground show cleanup was underway and plans for an improved city were moving forward. According to the *Marylander and Herald* of April 25, 1922, "A new city will arise out of the ashes for already, before they are cold, enterprising property **holder**s and businessmen are planning how quickly the rubbish can be removed and building operations begun." (Courtesy of Winnie Small.)

Four

RENEWED AND RESTORED

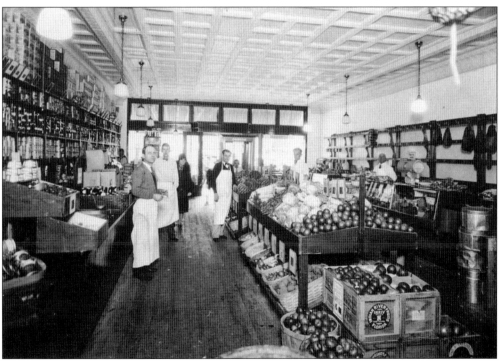

The wood-frame buildings destroyed by the fire were replaced with modern brick structures, and Pocomoke City enjoyed a renaissance. By 1930, some 2,600 people were living and working in the town, and businesses and houses had sprung up to accommodate them. The A&P store in downtown Pocomoke City, pictured in the early 1930s, offered a large selection of produce and other grocery items. The man in the left foreground has been identified as William Earl Small; the woman standing in the center is Madeline Bunting. (Courtesy of Winnie Small.)

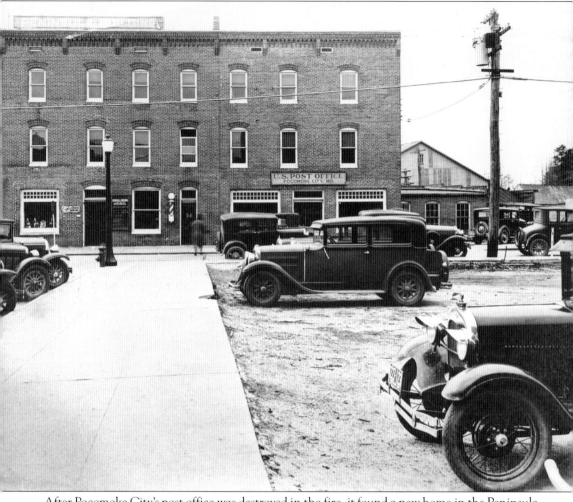

After Pocomoke City's post office was destroyed in the fire, it found a new home in the Peninsula Building, on the corner of Front and Market Streets. Carter's Beauty and Barber Shops were located next to the post office at street level, while other offices and businesses occupied the upper floors. (Courtesy of the Costen House Collection.)

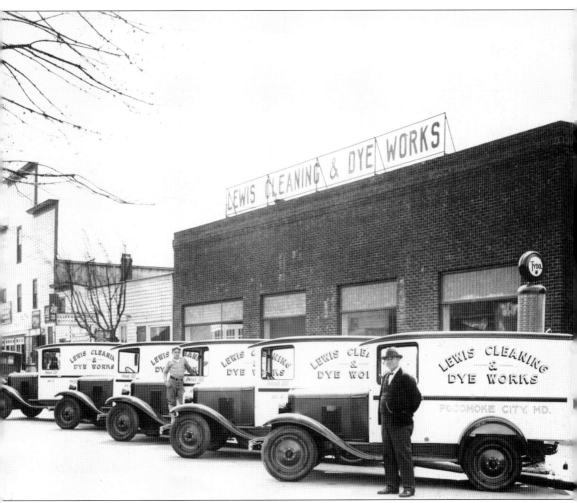

The Lewis Cleaning and Dye Works was located on Willow Street in the 1930s. Proprietor Norman Lewis presumably stands in the foreground of this view, in front of his fine delivery trucks. (Courtesy of the Costen House Collection.)

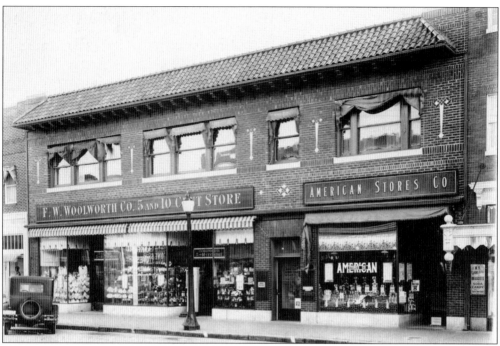

Downtown Pocomoke City boasted an F. W. Woolworth 5-and-10¢ and an American Grocery store in the 1930s, as seen above. Attorney L. Paul Ewell and chiropractor Dr. Biron had offices on the second floor. Below, F. W. Woolworth's employees pose behind neat counters offering candy, toys, glassware, and fabrics. Signs posted throughout the store read, "Nothing in This Store over 10 Cents." (Courtesy of the Costen House Collection.)

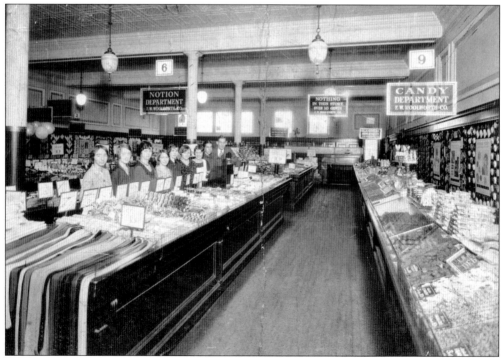

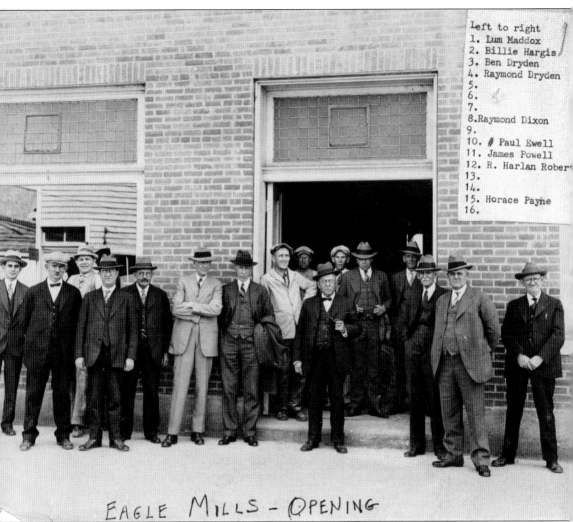

EAGLE MILLS - OPENING

This 1930s image represents the opening of Eagle Mills, a local grain mill and distributor located on the corner of Maple Street and Clarke Avenue. Shown from left to right are Lum Maddox, Billie Hargis, Ben Dryden, Raymond Dryden, three unidentified people, Raymond Dixon, unidentified, L. Paul Ewell, James Powell, R. Harlan Robertson, two unidentified people, Horace Payne, and unidentified. (Courtesy of the Costen House Collection.)

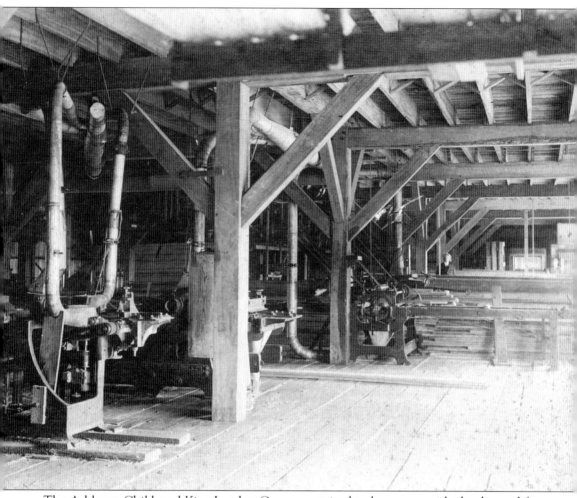

The Ashburn, Child, and King Lumber Company strived to keep pace with the demand for building materials after the fire of 1922. Business co-owner Quince Ashburn stands in the right background of this 1930s view of the mill interior. (Courtesy of the Costen House Collection.)

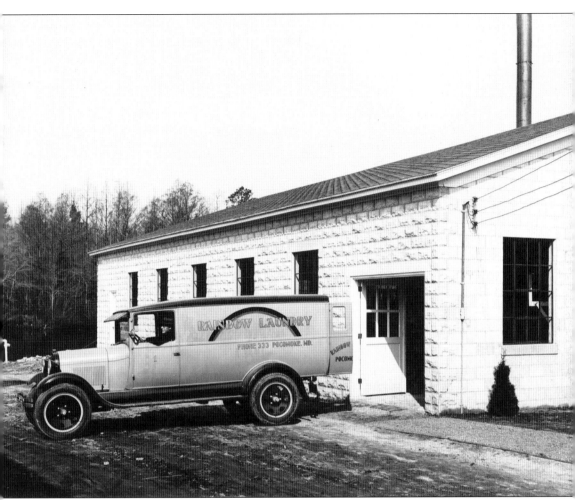

An artesian well, a deep well in which water is forced up by the pressure of underground water draining from higher ground, was located in the Laurel Street area of Pocomoke City. The Rainbow Laundry set up shop nearby. (Courtesy of the Costen House Collection.)

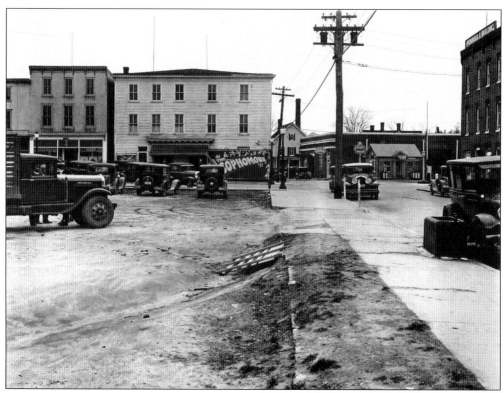

Taken in the mid-1920s, the above photograph shows the north end of Market Street at the corner of Front Street. This area of the business district survived the fire of 1922 relatively intact. The Empire Theatre, touting a production of *The Sophomore*, provided a venue for live shows in Pocomoke City, a real treat in a rural town. Pictured below is a program from *The Merry Whirl*, a minstrel production staged at the Empire Theatre in 1924. (Courtesy of the Costen House Collection.)

Souvenir Program

"The Merry Whirl"

THIRD ANNUAL

Petticoat Minstrel-Musical Revue

EMPIRE THEATRE
POCOMOKE CITY, MARYLAND

**Wednesday - Thursday - Friday
October 8-9-10, 1924**

AUSPICES OF

**Crescent Chapter, No. 44
Order Eastern Star**

Staged By The
WHEELER PRODUCING COMPANY
202 W. Chestnut St., Lancaster, Pa.

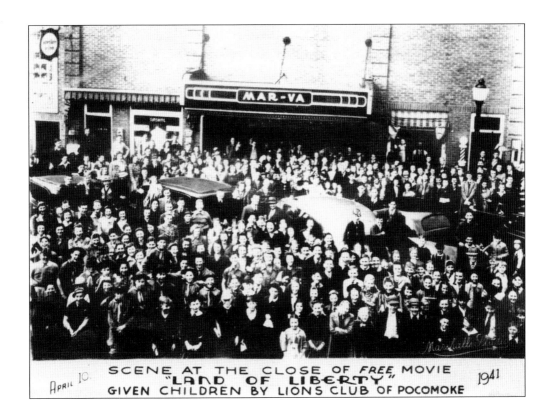

SCENE AT THE CLOSE OF *FREE* MOVIE
"LAND OF LIBERTY"
April 10. 1941
GIVEN CHILDREN BY LIONS CLUB OF POCOMOKE

A new theater, the Mar-Va, opened on Market Street on December 1, 1927. It featured a setback (step-like recessions emphasizing the squares) ceiling and other stylized geometric ornamentation common in art deco design. The theater showed movies and hosted vaudeville and minstrel shows; America's favorite singing cowboy, Roy Rogers, gave a live performance in the 1940s. The Mar-Va had a full dressing room and an orchestra pit. In the above exterior view of the 1940s, Pocomoke City's young people were just treated to a free showing of the movie *Land of Liberty* by the Lions Club. The Mar-Va's admission price was only 15¢. (Courtesy of Bill and Kate Matthews.)

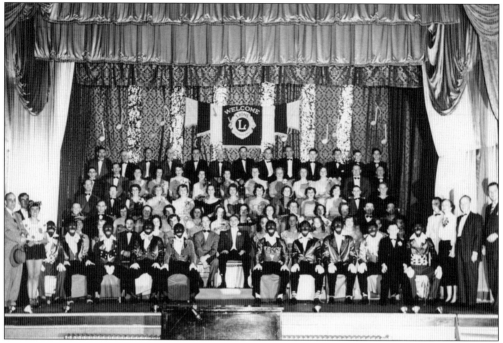

Minstrel shows, musical and comedy revues in which performers blackened their faces with burnt cork, began as early as the 1840s and continued into the 1950s in rural theaters. Shows featured variety acts, sentimental songs, music, and dancing. These photographs, taken in the 1950s, reveal the casts of two programs featuring minstrel performers on the lush stage of the Mar-Va Theatre. (Courtesy of Winnie Small.)

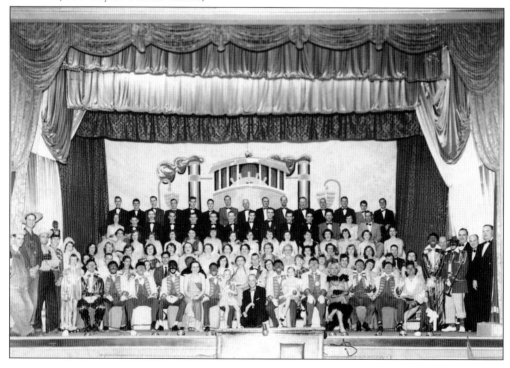

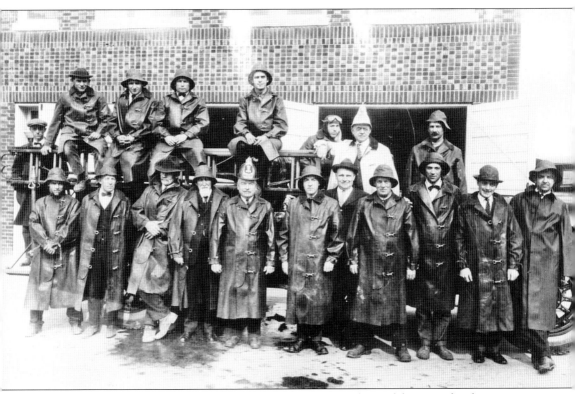

This picture, taken in 1926, shows Pocomoke City's firemen in front of their new fire department building on Willow Street. The original structure was destroyed by the fire in 1922. Many small communities surrounding Pocomoke City didn't have fire departments until the 1950s; the Pocomoke City Fire Company responded to fire calls in Stockton, Westover, and Rehobeth, Maryland, and to Atlantic, Oak Hall, Saxis, and New Church in neighboring Virginia. In 1931, the Ladies' Auxiliary was officially formed. The money raised at the public dinners put on by the ladies was used to buy much-needed fire equipment for the volunteer company. The fire company moved to a new, larger building on Fifth Street in 1939. (Courtesy of George Henderson.)

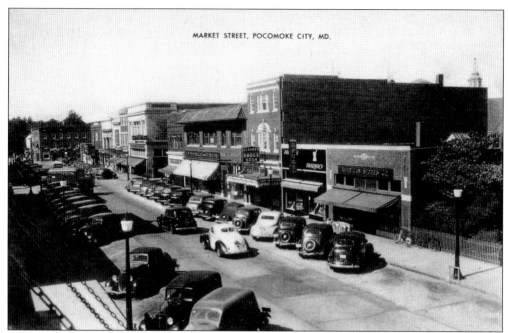

Modern brick structures proliferated in Pocomoke City's business district as rebuilding efforts continued. In the early 1930s, some 20,000 people lived within a 20-mile radius of Pocomoke City, and the town was glad to meet their needs for groceries, agricultural supplies, and other goods. A 1935 government report showed that Pocomoke City had purchasing power of $699 per capita—more than any other Maryland town with a population under 10,000. A resplendent Market Street is revealed in this 1930s view. (Courtesy of the Costen House Collection.)

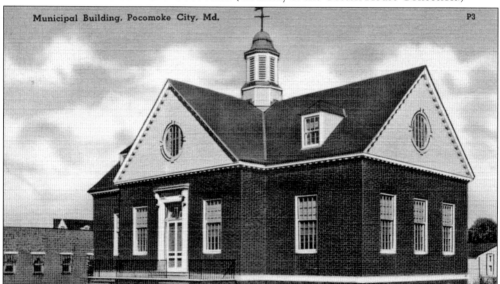

Municipal Building, Pocomoke City, Md. P3

The WPA was a government program implemented to help provide employment for some of the 10 million people unable to find jobs during the Great Depression. As a WPA project in 1936, Pocomoke City's municipal building was constructed in a modified Georgian Colonial style on Clarke Avenue. It housed city offices, a council room, a meeting room for clubs, and the public library. (Courtesy of Bill and Kate Matthews.)

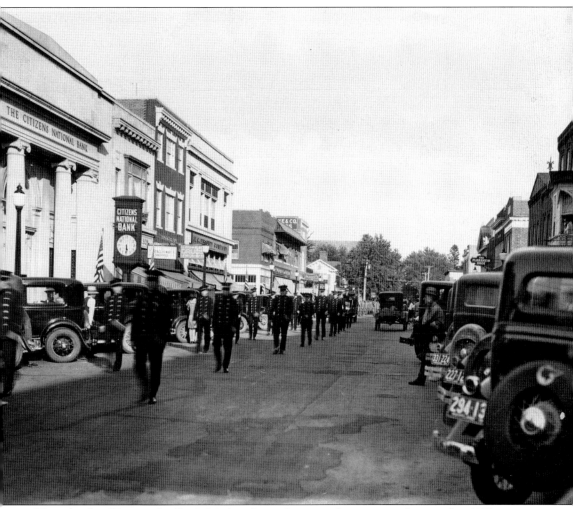

The rebirth of Pocomoke City's Market Street business district is evident in this 1930s view. The town's volunteer firemen march proudly down Market Street as part of a Memorial Day parade. The street is pristine, and the buildings, particularly on the left side of the street, are modern and grand. A few doors down from the Citizens National Bank building on the left is the Veasey Building, which housed J. C. Penney and, in the rear, Montgomery Ward. Economic growth continued unimpeded in Pocomoke City throughout the 1940s. (Courtesy of the Costen House Collection.)

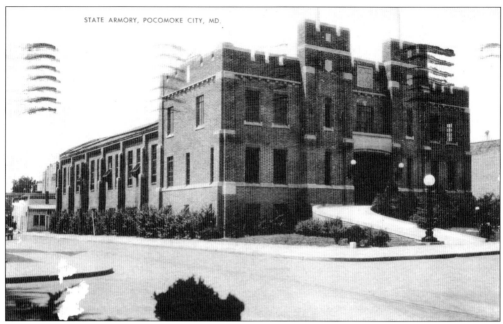

STATE ARMORY, POCOMOKE CITY, MD.

The Medieval Revival–style Maryland National Guard Armory (above) was constructed on Second Street in 1927. In 1923, local lawyer Godfrey Child had organized a Pocomoke City company of the Maryland National Guard. Gov. Albert C. Ritchie and adjutant general Brig. Gen. Milton Reckford approved the creation of Headquarters Company, 3rd Battalion, 1st Infantry. Pocomoke City's Home Guard (below) gathers in the armory gymnasium in 1940. (Courtesy of Carol Brittingham Wilkes.)

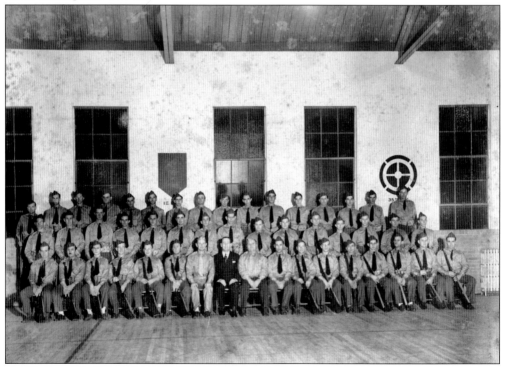

By the fall of 1946, the Maryland National Guard had been reorganized by the U.S. Army. Pocomoke City became Company M of the Headquarters Company, 3rd Battalion Infantry, based in neighboring Salisbury, Maryland. Pocomoke City's guard served honorably at home and abroad until its dissolution by federal order in 1968. Company M is pictured at Camp Ritchie, Maryland, in 1948. (Courtesy of the *Worcester County Messenger*.)

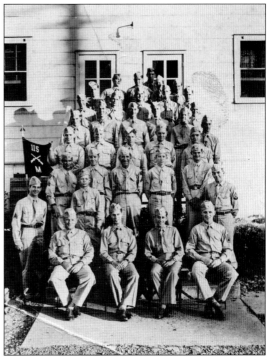

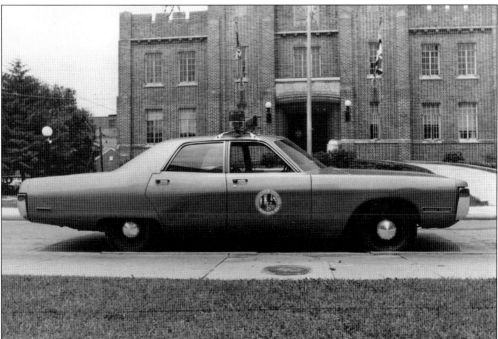

The distinctive armory building went on to house the Pocomoke City Police Department and the town's civic council. The fine gymnasium served as a recreation center, while the massive offices provided places for organizations to meet. This photograph, taken in the early 1970s, gives a good view of the building's buttressed, notched walls and the police department's newest cruiser. (Courtesy of the *Worcester County Messenger*.)

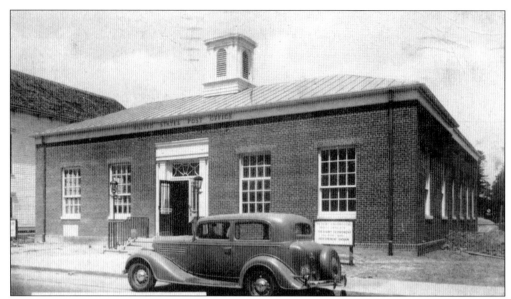

A new post office on Market Street, the result of a WPA project, was dedicated in 1937. (Courtesy of Bill and Kate Matthews.)

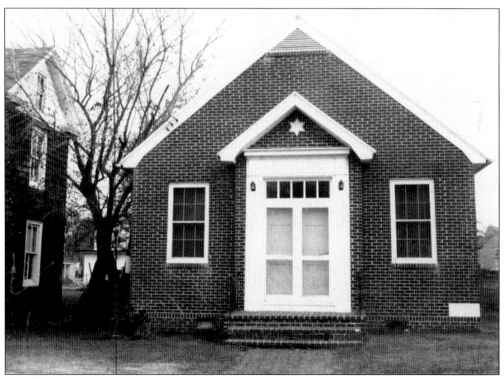

This Colonial-style Jewish synagogue was completed on Third Street near Linden Avenue in January 1948. Pocomoke City's Jewish community spent years meeting in local office buildings and community venues before acquiring its own place of worship. (Courtesy of the Costen House Collection.)

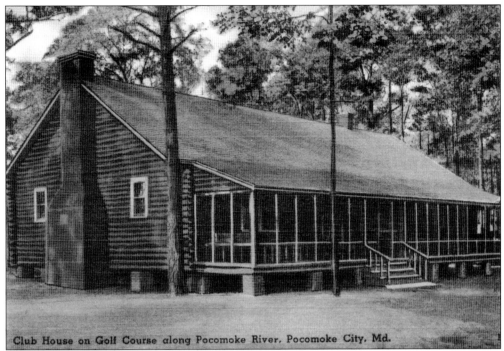

Club House on Golf Course along Pocomoke River, Pocomoke City, Md.

Another WPA project, the cypress log cabin pictured above was constructed in 1938. The building fronts a picturesque bend of the Pocomoke River and serves as a clubhouse for the adjacent nine-hole golf course. Through the years, it has held local civic and scouting groups and hosted dances, reunions, and parties. Below, Norma Polk (center, behind cake) celebrates her 15th birthday at the cabin in 1942. (Courtesy of Joe Mel Byrd.)

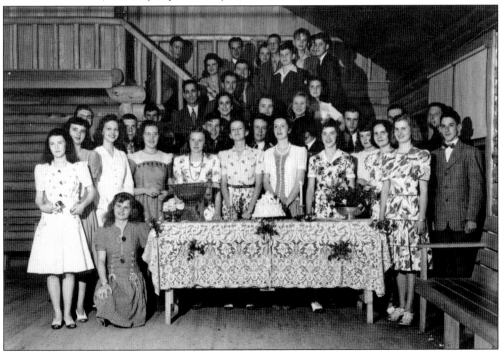

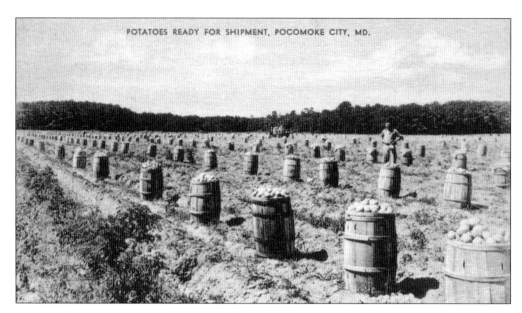

POTATOES READY FOR SHIPMENT, POCOMOKE CITY, MD.

Because of the tempering effect of the Atlantic Ocean and the Chesapeake Bay, the area around Pocomoke City has always been ideal for agriculture. Potatoes (above) and strawberries (below) are two of the crops abundantly produced for market. *A Capsule Sketch of Pocomoke City*, a brochure printed by the chamber of commerce in 1956, stated the following: "Because of its proximity to the nation's largest food consuming centers, marketing the area's produce is a simple matter. The farmer has but to pick or harvest the crops and take them to a central auction block where they are sold to the highest bidder, placed on trucks or in refrigerated cars and they are soon on their way to the wholesale markets of the East. In fact, much of the produce delivered to the auction blocks before five o'clock in the afternoon is found in the wholesale markets at two o'clock the next morning. Only a few hours later it is offered to the housewife over the counters of her favorite grocer." (Courtesy of Bill and Kate Matthews.)

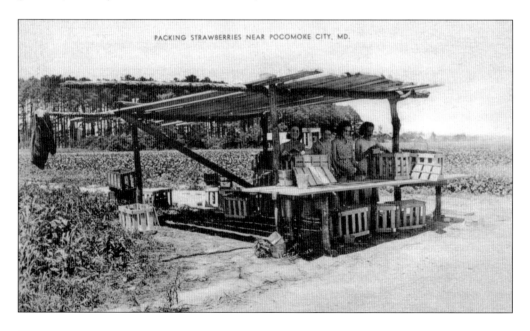

PACKING STRAWBERRIES NEAR POCOMOKE CITY, MD.

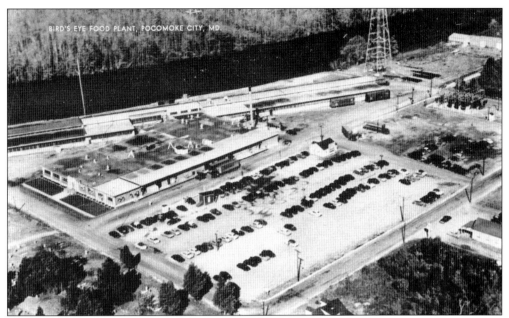

In 1942, the Birds Eye Division of the General Foods Corporation constructed a chicken processing plant in Pocomoke City. The food plant provided up to 800 jobs for area workers. Shown here is an aerial view of the site on Clarke Avenue. This plant was in operation for 23 years before Campbell Soup bought the facility in 1965. (Courtesy of the Costen House Collection.)

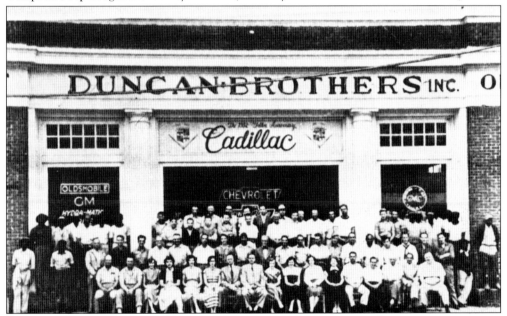

The Duncan brothers—Linwood, Orville, Clarence, and Marion—were early entrepreneurs in town. Their massive brick automobile showroom, the former Clogg's Garage, bordered the Pocomoke River at the foot of the drawbridge. They had a used car lot on the opposite side of Market Street and insurance and real estate businesses in the nearby Peninsula Building. Here the staff of the Duncan Brothers business poses in front of the automobile showroom in 1952. The car dealership operated from about 1928 to the 1960s. (Courtesy of Bill and Kate Matthews.)

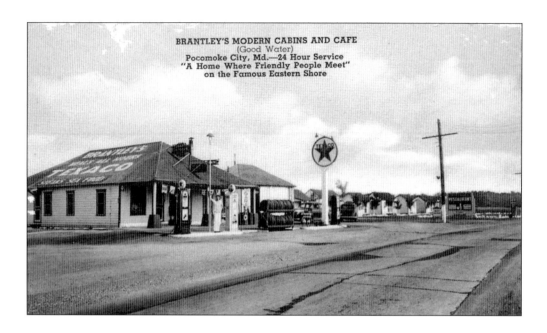

BRANTLEY'S MODERN CABINS AND CAFE
(Good Water)
Pocomoke City, Md.—24 Hour Service
"A Home Where Friendly People Meet"
on the Famous Eastern Shore

Established in 1926, U.S. Route 13 runs for more than 500 miles from northeastern Philadelphia to just north of Fayetteville, North Carolina. Brantley's Modern Cabins and Café, pictured above on a 1930s postcard, offered Texaco gas and "good water" to travelers on the route. This modest rest stop, a few miles south of Pocomoke City, was a forerunner of the sleek Twin Tower Motel, shown below. The distinctive glass-block towers became landmarks, and the motel, with its well-appointed rooms and restaurant, welcomed guests to Pocomoke City for over 30 years. (Courtesy of Bill and Kate Matthews.)

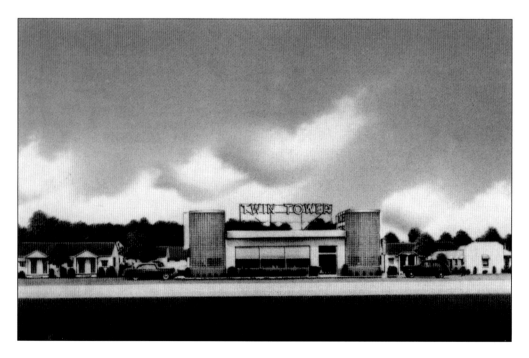

Philip and Rose Scher opened a clothing store in the Callahan Building on Market Street in 1933. Scher's featured fine fashions and accessories for men, ladies, and children. The name was synonymous with style, and the store became a shopping destination. The advertisement (right) announces the 50th anniversary of the store in 1983. Scher's remained a family-run business; Philip and Rose's son Irvin (pictured below in the 1970s) and his wife, Doris, maintained the store's reputation for "Smart Wear" and personal service. Irvin and Doris's son Marc and daughter-in-law Judi continue to operate Scher's at the same location today. (Courtesy of Marc Scher.)

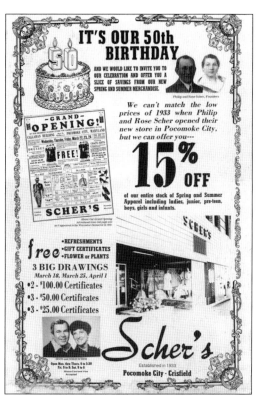

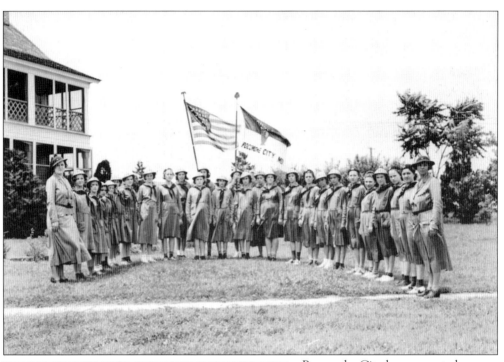

Pocomoke City has supported many civic groups, clubs, and community organizations throughout its history. As early as 1888, the Inasmuch Circle of the Kings Daughters formed in the town to minister to the "spiritual and financial needs of the poor." Most nationally organized service clubs were represented in Pocomoke City. Here local Girl Scouts gather at nearby Public Landing in 1936. (Courtesy of the Costen House Collection.)

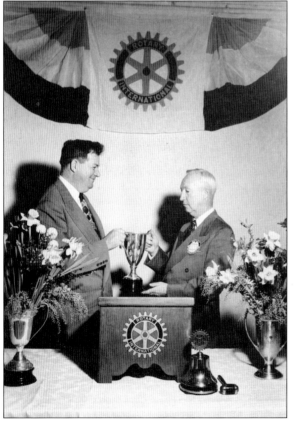

Pocomoke City's Rotary Club, a community service club for "business men of all lines," received its charter in 1923. In this 1948 photograph, club president Norman Polk (left) presents charter member H. Merrill Walters (right) with a silver cup to honor his 25 years of perfect attendance at meetings. (Courtesy of Norma Miles.)

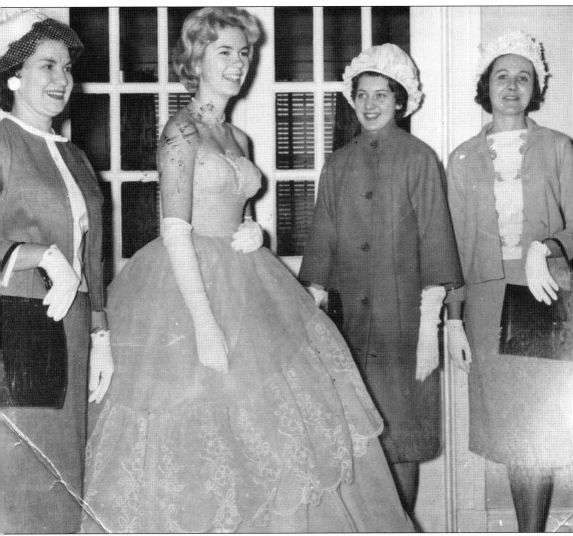

The Woman's Club of Pocomoke City worked hard to support local charities. Fashion shows featuring the latest styles from local stores served as successful fund-raisers. This photograph was taken at a show held at the local fire hall in the early 1960s. Pictured from left to right are Mrs. Kip Killmon, representing Callahan's department store; Merrill Lee Walters, representing Coffman-Fishers; Betty Anne Payne, in fashions from J. C. Penney; and Mrs. Richard Bunting, in clothing from Scher's. (Courtesy of the Costen House Collection.)

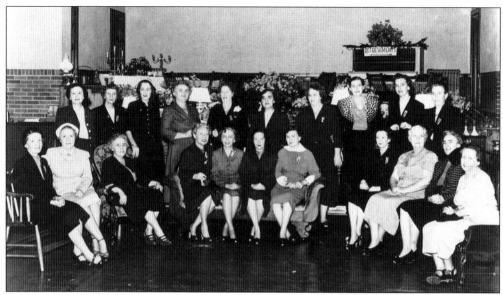

Soroptimist International of Pocomoke City was established in 1952 based on the ideals of "the sincerity of friendship, the joy of achievement, the dignity of service, the integrity of profession, the love of country." Charter members are shown above. The determined group of 22 business and professional women recognized the need for a home for the aged and set about acquiring and developing a suitable property. They speedily formed a corporation and began to look for a site that would be "a home in every sense of the word and not just a public institution." When a stately home owned by Stella Stevens became available on Market Street (below), members felt it would be ideal for their purpose and put down $1,800, the proceeds from a recent antique show. Through tireless fund-raising and with unwavering community support, Hartley Hall Home for the Aged was paid for within five years of its purchase. The Soroptimist Club continues to support the nursing home through volunteer efforts and also contributes to many other community projects and scholarship programs. (Courtesy of Beulah Baylis.)

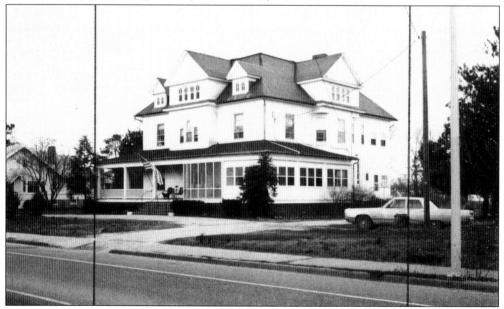

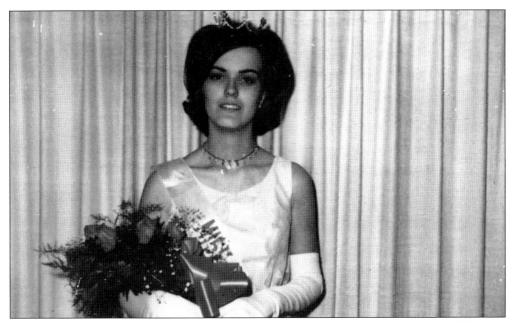

The Junior Women's Club formed in 1950 in affiliation with the General Federation of Women's Clubs, one of the world's largest and oldest volunteer organizations for women. Since 1956, the group has been organizing and sponsoring the Miss Pocomoke and Little Miss Pocomoke Pageants. Pageant winners receive gifts and monies from local merchants, and proceeds benefit college scholarship programs for local students. Darlene Outten, seen here, was named Miss Pocomoke in 1969. (Courtesy of Darlene Dean.)

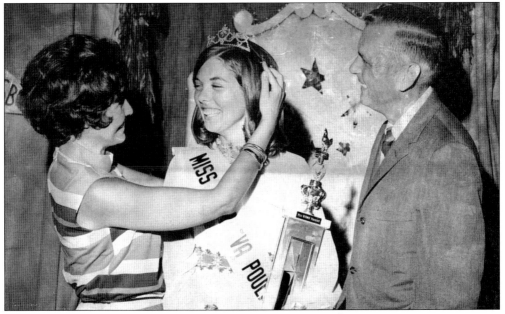

For many years after its inception, the winner of the Miss Pocomoke Pageant went on to represent the town in the Delmarva Poultry Princess Contest sponsored by the Delmarva Poultry Industry. Miss Pocomoke 1970, Diane Bunting, also captured the Delmarva crown. (Courtesy of the *Worcester Democrat*.)

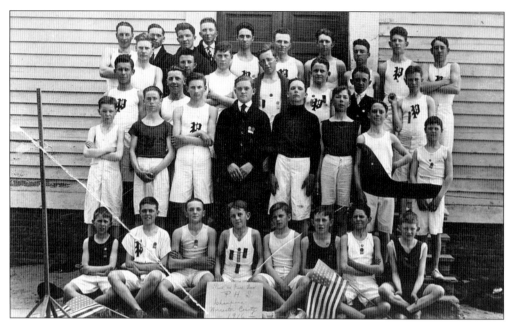

The people of Pocomoke City have always supported school and community athletics. Here members of the 1916 Pocomoke High School track and field team commemorate their Worcester County championship. (Courtesy of Bill Kerbin.)

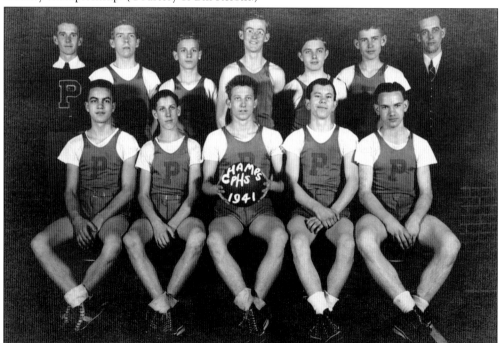

Members of the Pocomoke High School boys' basketball team pose for a portrait during their championship season in 1941. Shown from left to right are the following: (first row) Johnny Smullin, Joe Byrd, Bill DeMar, Adrian Darby, and Roger Mariner; (second row) Eddie Vincent, Lee Wilkinson, Bill Birch, L. J. Duncan, Bill Small, Jack Payne, and unidentified. (Courtesy of Winnie Small.)

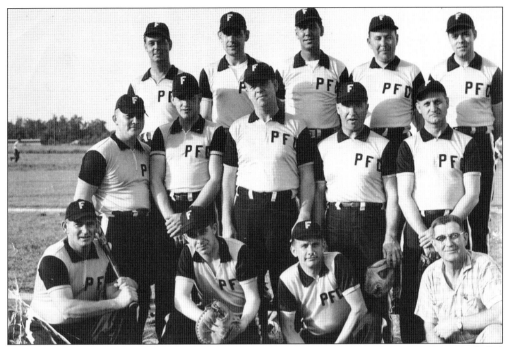

The Pocomoke Fire Department fielded a baseball team for many years. The 1945 season included the following players: from left to right in the first row are Jim Willing, Birdie Miles, Norman Nock, and H. Henderson; the second row includes Vernon Massey, LeRay Thompson, Earl Lewis, and Pete Dulick; the third row is, from left to right, Dick Thompson, Wimp Corbin, Joe Byrd, Marion Butler, and Sonny Henderson. (Courtesy of Evelyn Hancock.)

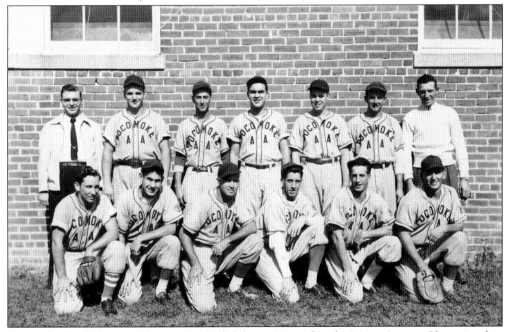

Pocomoke City's Athletic Association ball club participated in the Marva League Championship Series in 1948. (Courtesy of Winnie Small.)

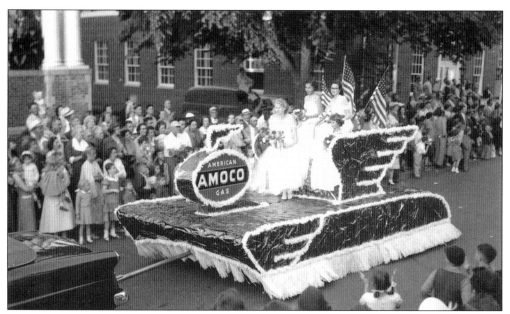

Poultry growing and processing has been a big part of Pocomoke City's economy through the years; by the 1950s, Worcester County had become the second ranking poultry-producing county in the nation. In addition to those engaged in growing poultry and those working in the hatcheries and processing plants, hundreds of people were employed in the sale and delivery of the birds. Since 1949, the Delmarva Poultry Industry has celebrated its success with the annual Delmarva Chicken Festival. Area communities take turns hosting the festivities, which include entertainment, cooking contests, carnival rides, and loads of chicken prepared in a specially made frying pan. The pan is 10 feet in diameter with an 8-foot handle and requires 180 gallons of cooking oil to fill. These photographs were taken in 1952, when Pocomoke City hosted the festival for the first time. A gala parade down Market Street featured floats sponsored by area businesses, including the Miles Oil Company (above) and the Small and Bull Hatchery. (Courtesy of the Preston and Mary Marshall estate.)

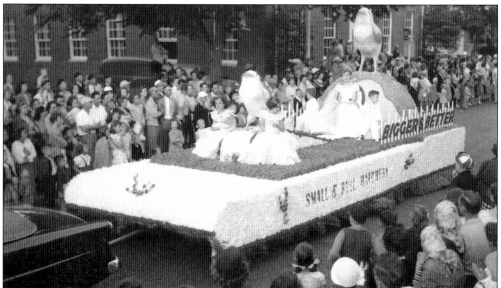

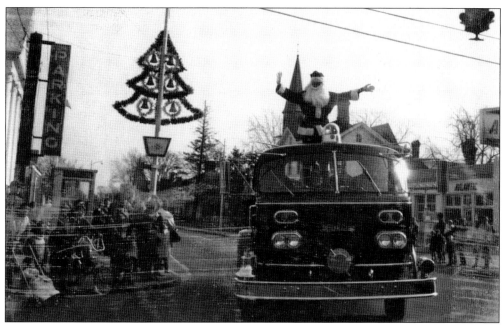

The Pocomoke City Chamber of Commerce sponsors entertainment for the community and promotes local businesses. The Pocomoke City Christmas Parade has been an exciting attraction on Market Street since the 1960s. Above, audience members enjoy the long-anticipated arrival of Santa—by fire truck—in the late 1960s. Since the 1970s, the parade has been held on the first Monday night after Thanksgiving and has earned the distinction of being "the largest nighttime parade on Delmarva." (Courtesy of the *Worcester County Messenger*.)

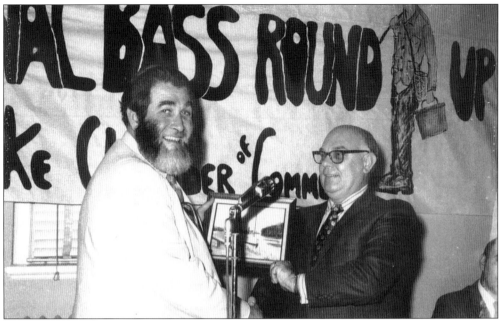

In 1960, the Pocomoke City Chamber of Commerce inaugurated the National Bass Roundup. Local ponds and waterways were stocked with fish bearing special tags; anglers who landed tagged fish received money and prizes from local sponsors. The fish were purchased from state fisheries and kept in a local motel swimming pool until they could be placed in nine local ponds and the Pocomoke River. The contest ran each year from May 1 through October 31. Bill Burton, a well-known television and radio personality and writer of outdoor life columns for the *Baltimore Sun*, was the guest speaker at the awards banquet in 1970. Above, Burton receives a painting of the Pocomoke River by local artist Ruth Westfall in appreciation for his attendance and support. Below, he makes a catch of his own. (Courtesy of the *Worcester County Messenger*.)

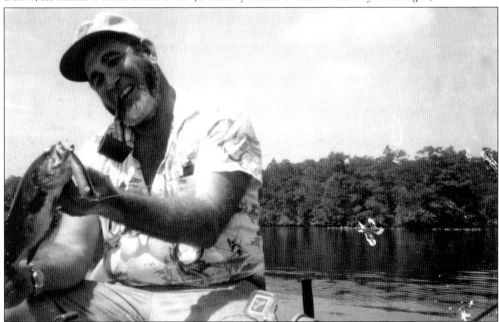

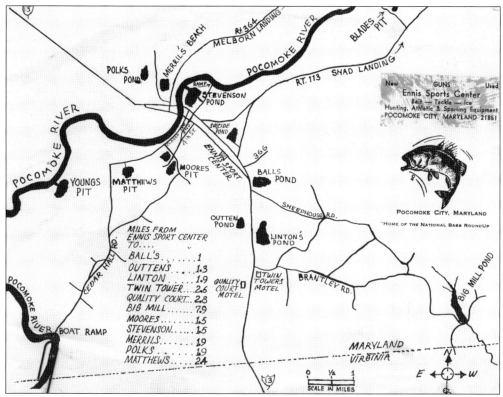

This map, drawn by Ruth Westfall and distributed by Ennis Sports Center, directed local fishermen to the stocked ponds. Pocomoke City was home to the National Bass Roundup until the program's demise in the mid-1970s. (Courtesy of the Costen House Collection.)

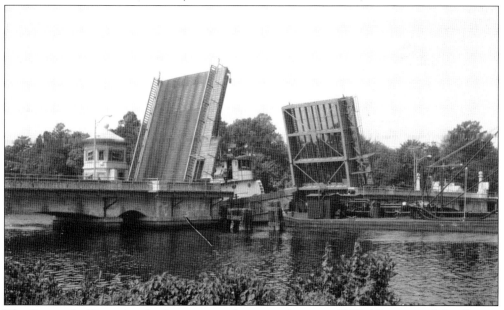

The Pocomoke River drawbridge opens to let a vessel pass in 1965. (Courtesy of the Costen House Collection.)

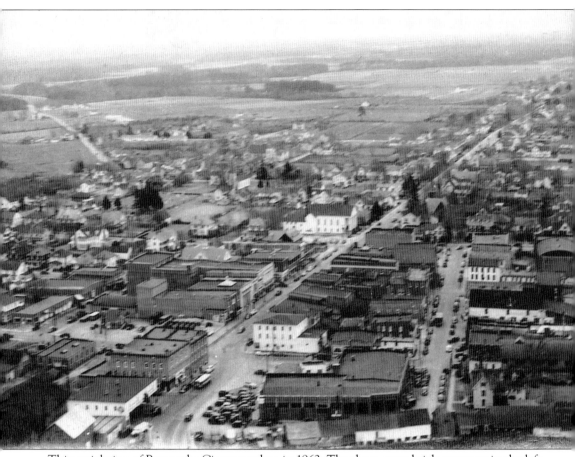

This aerial view of Pocomoke City was taken in 1962. The three-story brick structure in the left foreground is the Peninsula Building. The two-story white building near the center is Bethany Methodist Church. (Courtesy of the Preston and Mary Marshall estate.)

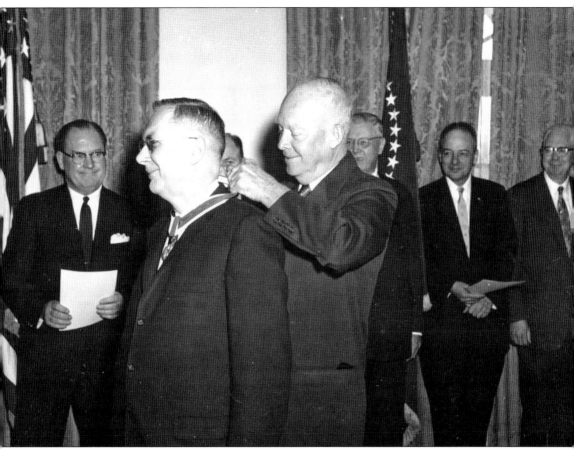

A naval air station opened on nearby Wallops Island, Virginia, in 1943. The influx of people associated with the navy base proved a boon to Pocomoke City's economy. When the base closed in the late 1950s, a division of NASA moved in. The array of aerospace programs at the facility, combined with the associated contracting groups, continued to provide jobs and revenue to the area. Pocomoke City native Dr. Hugh Dryden (1898–1965) was an aerodynamicist serving as NASA deputy administrator from August 1958 until his death. His awards include a Presidential Certificate of Merit, a National Medal of Science in Engineering, 16 honorary doctorates, and a crater on the moon named after him. Dryden was portrayed by George Bartenieff in the 1998 miniseries *From the Earth to the Moon*. Here he is receiving a medal from Pres. Dwight D. Eisenhower. (Courtesy of the Costen House Collection.)

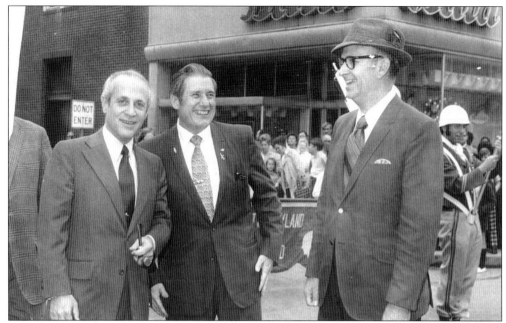

Pocomoke City mayor J. Dawson Clarke (right) welcomes Gov. Marvin Mandel (left) and Sen. Elroy Boyer on Market Street in 1970. Boyer served as a Maryland state senator until 1978 and then went on to serve as a circuit court judge. Governor Mandel held the office until 1979; he was forced to turn over his duties to Lt. Gov. Blair Lee before the end of his term after he was convicted of mail fraud and racketeering. (Courtesy of the Costen House Collection.)

Rogers C. B. Morton (right) shakes hands with constituent Mark Callahan (left) during a campaign stop on Market Street in the 1960s. Morton served the First Congressional District of Maryland from 1963 until 1971 and was a vice presidential hopeful at the 1968 Republican National Convention. He went on to a career as secretary of the interior and secretary of commerce before his death in 1979. (Courtesy of the Costen House Collection.)

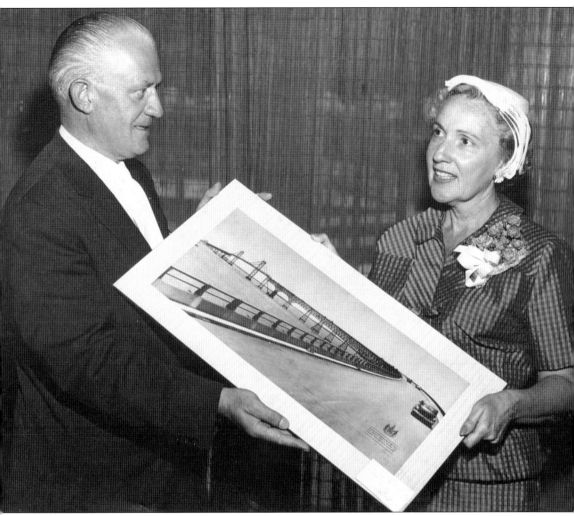

Local politico Myrtle Ashburn Polk (1902–1995) wielded the proverbial iron fist in a velvet glove. Her old-fashioned gentility and grace belied her determination and spirit. In 1948, she became the first woman elected to the Pocomoke City Town Council and graciously accepted her appointment as head of the sanitation department. Polk was elected to the Maryland House of Delegates in 1950 and served seven and a half years in the legislature. She remained politically active upon returning to Pocomoke City and was instrumental in organizing several groups, including the Worcester County Garden Club and the Levin Winder Chapter of the Daughters of the American Revolution. Here Polk receives a photograph of the Chesapeake Bay Bridge from one of the engineers involved in its construction. The span was completed in 1952 while Polk was serving in the General Assembly. It connected the state's eastern and western shores, eliminating the need for ferries. (Courtesy of Norma Miles.)

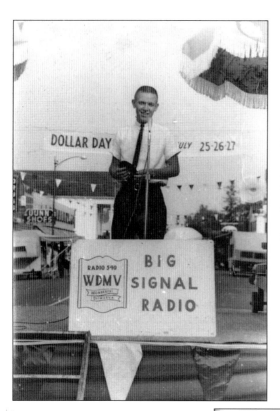

There was no shortage of media in Pocomoke City; the town provided a fine weekly newspaper as early as 1880. The *Worcester Democrat*, founded in 1898, and the *Ledger Enterprise*, founded in 1880, merged in 1920 under the *Worcester Democrat* banner. In 1955, WDVM (later WDMV) radio began broadcasting. Taken during a live broadcast at a busy Market Street intersection in 1960, this photograph shows James "Choppy" Layton behind the microphone. In 1958, Choppy started spinning records at the station for 75¢ an hour and became famous locally for the Chop Hop record hops he hosted. (Courtesy of Choppy Layton.)

Eddie "Momma's Country Youngin'" Matherly hosted live broadcasts from local nightclubs and featured a variety of hillbilly music on his daily shows at WDVM. Dated 1956, this poster states, "Eddie frequently brings big-name 'Country Music' stars to the Eastern Shore, thus furnishing his fans with the best in live hillbilly entertainment." (Courtesy of Choppy Layton.)

This is Eddie Matherly

"Eddie is heard on the "Country-Music" portion of WDVM's "CARAVAN" from sign-on until 8 A. M., 6 days weekly, and on WDVM's "Delmarva Jamboree" from 12:30 until 3, 6 days weekly."

he's the man who . . .

won the award "Mr. D. J., U. S. A." on WSM, Nashville, Tenn., and was chosen as the star on "Command Performance" at WWVA, Wheeling, W. Va. BOTH IN THE SPACE OF 4 MONTHS in 1956! He is an engaging personality both on the air and off. He is dynamic; easy to listen to! He has a thorough knowledge of the "Country-Music" field and is personally acquainted with many of it's top stars. Although Eddie has had offers from many of the top "Country-Music" stations, he is happy at WDVM. Eddie frequently brings big-name "Country-Music" stars to the Eastern Shore, thus furnishing his fans with the best in live hillbilly entertainment. He also has four local bands which play under his auspices in nite spots through-out the area. Eddie's personality, his genuine knowledge of "Country-Music" and his tremendous vitality make him THE TOP PERSONALITY IN THIS AREA.

540 on your dial **W D V M** 500 watts power

Pocomoke City, Maryland

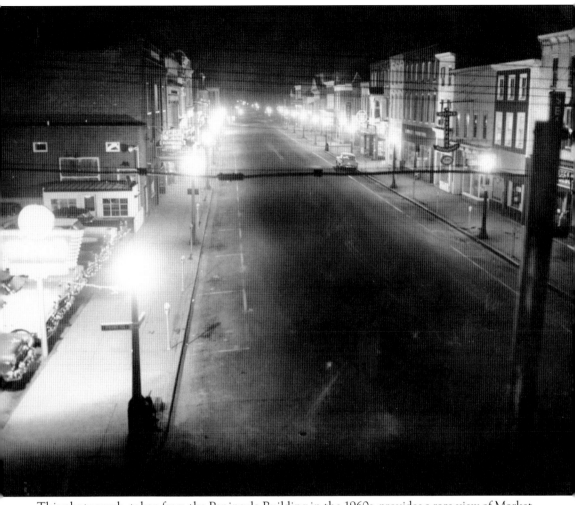

This photograph, taken from the Peninsula Building in the 1960s, provides a rare view of Market Street at night. The Duncan Brothers car lot is on the left, and the Mar-Va Theatre is located just past it. The Mar-Va is showing *Trapeze*, a movie starring Burt Lancaster. (Courtesy of the Preston and Mary Marshall estate.)

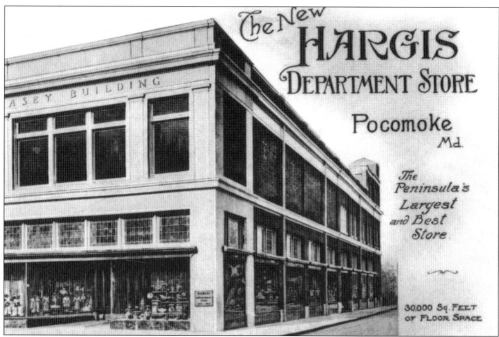

The 1970s brought changes to Pocomoke City's downtown area. Shown below is the razing of the grand Veasey Building. Politician and businessman Milton Veasey lost his previous commercial building in the fire of 1922, and when it came time to rebuild, he promised the "biggest, best and most complete department store on the entire peninsula." That building, pictured above, was constructed as the Hargis department store on the corner of Market Street and Clarke Avenue and extended the length of the block to Vine Street. J. C. Penney and Montgomery Ward were later housed in the T-shaped, two-story building until the 1960s. The building had various retail tenants; Daniel's department store was the last, surviving until demolition in 1976. A small park was subsequently constructed on the lot. When the commercial center of town began to shift away from the downtown area to Route 13, residents realized the need to revitalize and reclaim the historic district. (Courtesy of Winnie Small.)

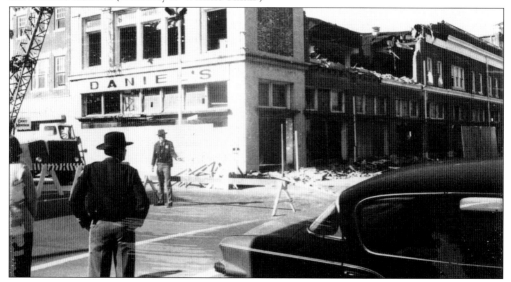

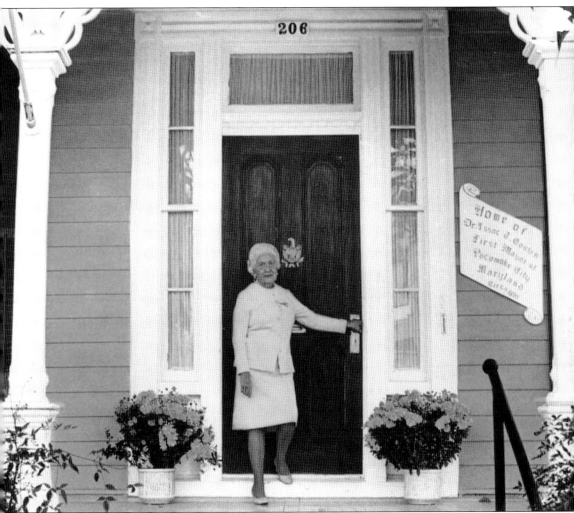

Myrtle Polk, local politician and former state delegate, founded the Spirit of Newtown Committee in 1974. Costen House, the home of Pocomoke City's first mayor, Dr. Isaac Costen, was slated for demolition. The house had been built in 1870 but remained in decent condition and represented a great period in Pocomoke City history. Polk and her fellow committee members appealed to the city council to put a referendum on the ballot to decide if the house should be sold to the Spirit of Newtown Committee or razed. The people of the town voted to save the house, and with help from the Maryland Historic Trust, it was purchased by the group. The home was placed on the National Register of Historic Sites, painstakingly furnished and restored, and opened to the public as a museum. In this photograph, Myrtle Polk welcomes visitors to the grand front porch of Costen House. (Courtesy of the Costen House Collection.)

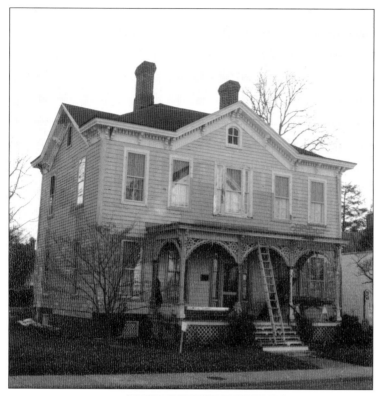

Costen House is pictured during a period of its restoration. The upstairs porch on the back of the house, below, had been used as a sick room for young William Costen, who suffered from tuberculosis. (Photographs by John C. Brinton.)

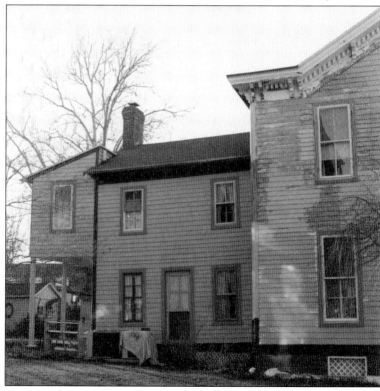

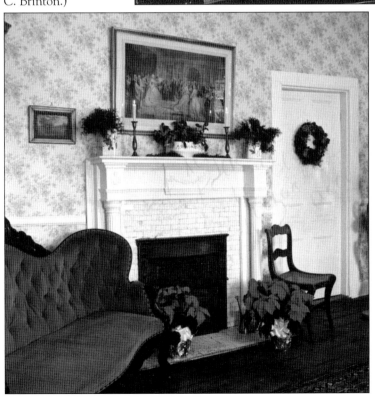

The house features fine examples of late-19th- and early-20th-century furniture, linens, and clothing. Many of the home's original furnishings, below, have been returned through donations or purchases made by the Spirit of Newtown Committee. (Photographs by John C. Brinton.)

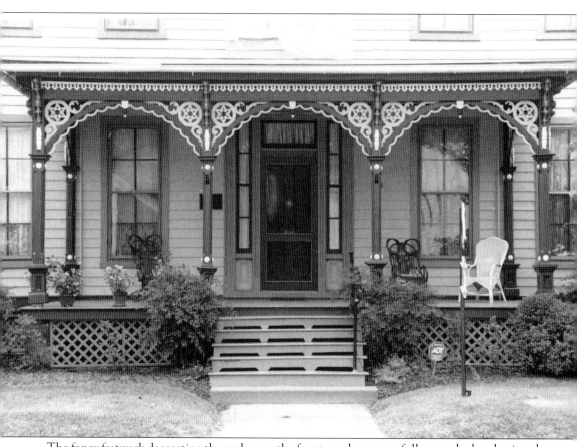

The fancy fretwork decorating the arches on the front porch was carefully reworked and painted. The Victorian Italianate style remained popular in this country until the late 1870s. There are fewer houses and other buildings of this design in the Deep South because it reached its peak just after the Civil War, when the South was economically disadvantaged. (Photograph by Paul Tuart.)

The entrance hall is decorated in anticipation of Christmas guests. Each year, Costen House sponsors a holiday house tour in town, giving citizens an opportunity to see some of Pocomoke City's oldest and grandest homes decorated for the holidays. (Photograph by John C. Brinton.)

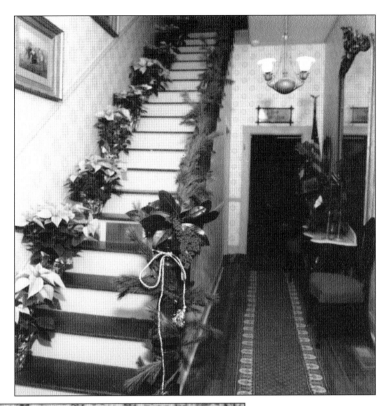

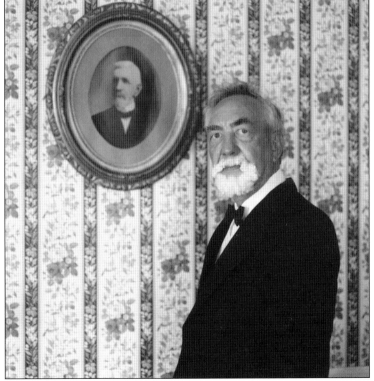

Larry Matthews often portrays Dr. Costen at Costen House fetes. Here he poses by the portrait of Dr. Costen hanging in the parlor. (Photograph by John C. Brinton.)

The property adjacent to Costen House was purchased by Julia Hall-Walton, a cousin of the Costens, in 1979. She gave it to the Spirit of Newtown Committee for use as a garden. A curved brick walkway and gazebo invite visitors to stroll, while benches beckon them to sit and enjoy the sights and fragrances that abound, as displayed at left. Below, the Community Singers celebrate May Day, complete with a maypole, in the Hall-Walton Memorial Garden in 1983. (Left photograph by John C. Brinton; below photograph by W. R. Schlining.)

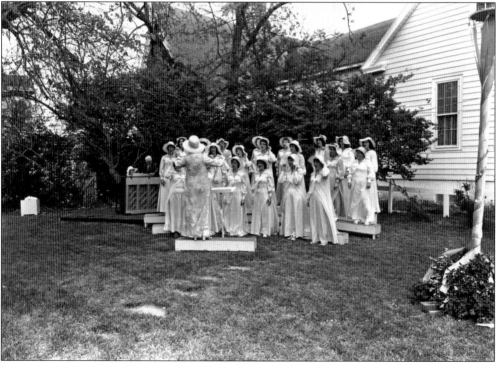

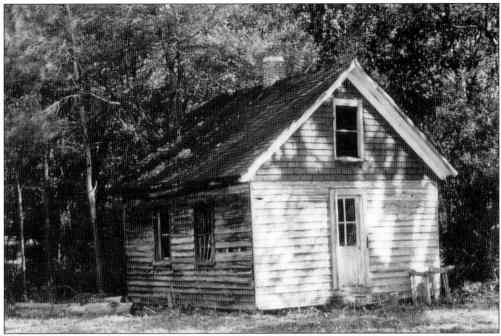

The Sturgis One Room School served African American students in Pocomoke City for 37 years. The small wooden structure, built around 1900 on land purchased by William Sturgis in 1888, housed grades one through seven and one teacher. William Sturgis returned to make his home in the building for several years after the school closed; when he left, the unused building became dilapidated. (Courtesy of the Sturgis One Room School Museum.)

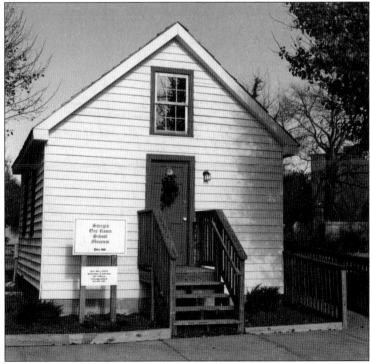

The schoolhouse was moved from its Brantley Road location to downtown Pocomoke City in 1996. A group of concerned citizens, under the leadership of the Worcester County Historical Society, purchased the building from the Sturgis family and worked to restore and furnish it. (Photograph by John C. Brinton.)

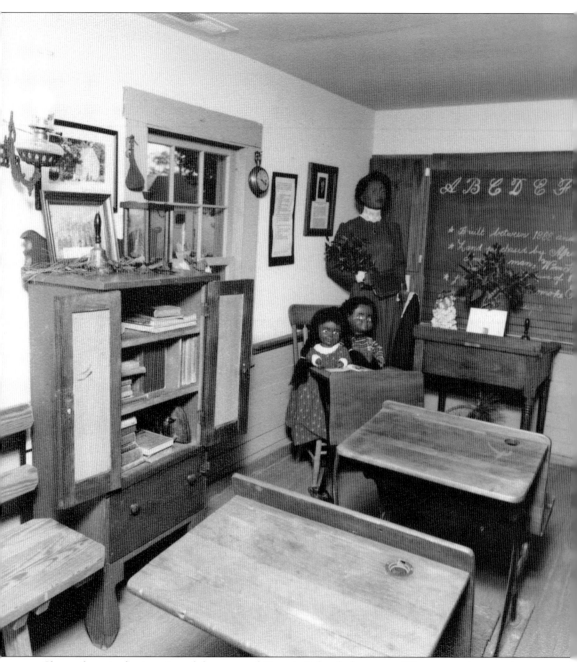

Shown here is the interior of the restored Sturgis School classroom. The restoration sought to preserve the somewhat primitive flavor of the unique building. The mission of the Sturgis One Room School Museum is to protect and promote the facility and to educate visitors and the community about its cultural significance. (Photograph by John C. Brinton.)

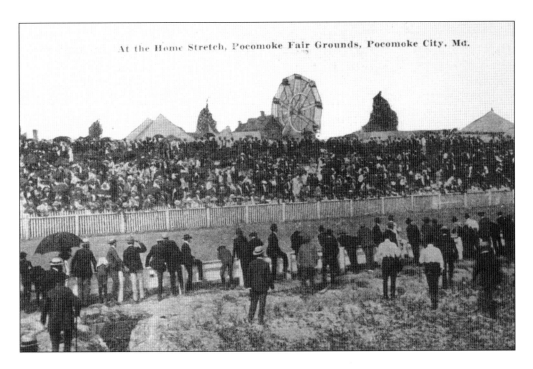

At the Home Stretch, Pocomoke Fair Grounds, Pocomoke City, Md.

The original Pocomoke Fair began in 1901 and was discontinued in 1930. As part of the town's commitment to celebrating its heritage, the Broad Street grounds were refurbished and the fair was reborn in 1991. In the above postcard view, fairgoers watch the horse races in the early 1900s. Below, horses parade to the starting post on the restored racetrack in 1995. (Courtesy of the Wigglesworth family.)

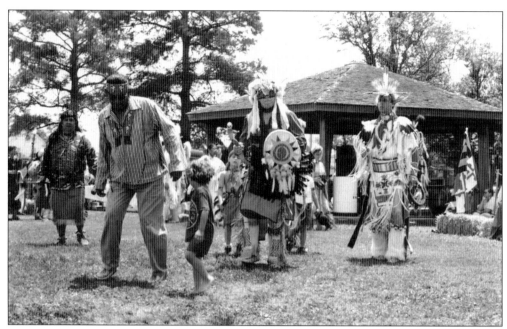

Native Americans have been gathering for an annual powwow on the banks of the Pocomoke River since 1993. Cypress Park hosts the celebration, which includes singing and dancing, crafts, and unusual and traditional food offerings. All area tribes are welcome at the gathering for a true representation of the town's early history. Here Native American dancers attempt to teach a young visitor a traditional dance. (Courtesy of the *Worcester County Messenger.*)

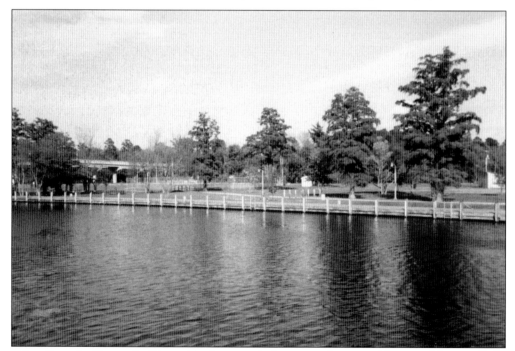

Taken from the Pocomoke River, this photograph showcases the natural beauty of Cypress Park. (Courtesy of Pocomoke City Hall.)

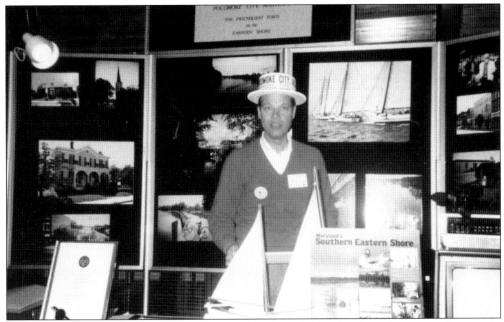

In 1984, Pocomoke City was selected to participate in the All-American Cities awards program. Established in 1949, the program recognizes "communities, large and small, that facilitate effective citizen leadership, use local resources to solve community problems, reform local government, and translate concern into action and success." Mayor J. Dawson Clarke, town manager Russell Blake, and a small contingent representing the city council and other community groups traveled to San Antonio, Texas, in November to represent the town. With a population of 3,558, Pocomoke City was the smallest of the 17 chosen cities. In this photograph, Russell Blake mans a display booth at the event featuring information about Pocomoke City. (Courtesy of Pocomoke City Hall.)

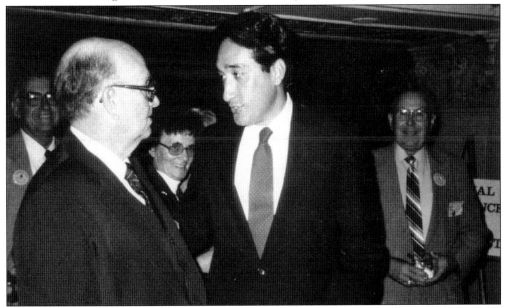

Mayor Henry Cisneros of San Antonio greets Pocomoke City mayor J. Dawson Clarke (left). (Courtesy of Pocomoke City Hall.)

MARYLAND
HOUSE OF DELEGATES

House Resolution

Be it hereby known to all that

The House of Delegates of Maryland

offers its sincerest congratulations to

POCOMOKE CITY, MARYLAND

in recognition of

ITS SELECTION AS ONE OF SEVENTEEN FINALISTS
IN THE 1984 – 1985 "ALL AMERICA CITIES" COMPETITION!
GO FOR IT!

The entire membership extends best wishes on

this memorable occasion and directs this resolution

be presented on this 8TH day of MARCH 19 85.

Benjamin L. Cardin
Speaker of House

Chief Clerk

DELEGATES PILCHARD, RILEY AND LONG
Sponsor

House Resolution 188

The town received congratulations from the Maryland House of Delegates on its selection as a finalist in the competition. (Courtesy of Pocomoke City Hall.)

118

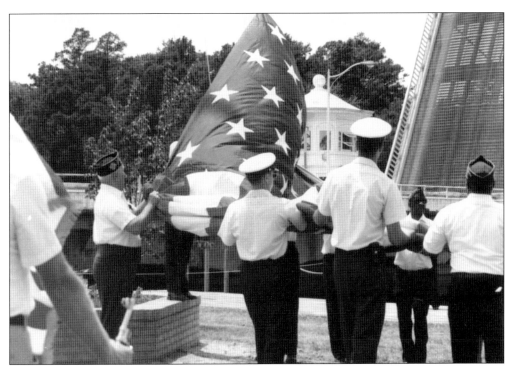

Pocomoke City was not chosen as a winning city, but the honor of being included in the competition was embraced by the community. On June 22, 1985, a beautiful new American flag was presented to the city by the VFW to recognize the town's participation. In the above photograph, the 20-by-30-foot flag is raised at the plaza near the foot of the drawbridge. The commemorative plaque below identifies Pocomoke City as the "friendliest town on the Eastern Shore." (Courtesy of Pocomoke City Hall.)

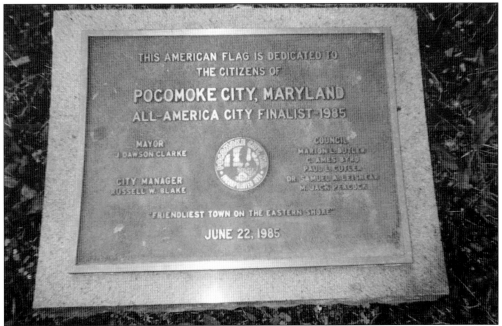

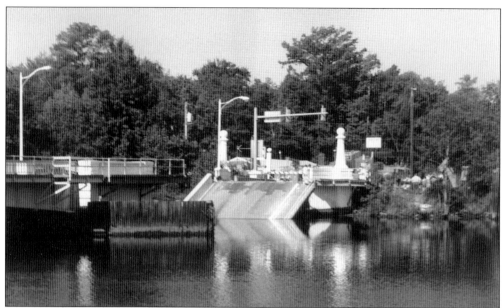

On August 17, 1988, at about 1:00 a.m., an 85-foot section of the 275-foot Pocomoke City drawbridge collapsed into the river. No vehicles were involved, and no one was injured. Completed in 1921, the bridge had last been inspected in 1986 by Northeast Engineering. At that time, some questions were raised about the condition of the span's support pilings, but no action was deemed necessary. Quick action was taken after the collapse, however, and with the unfailing support of Gov. William Donald Schaefer, the bridge was rebuilt and opened to traffic in less than a year. The image above shows the portion of the bridge that fell 30 feet into the river. Below, onlookers survey the river from the part that remained in place. (Courtesy of Chris Miles.)

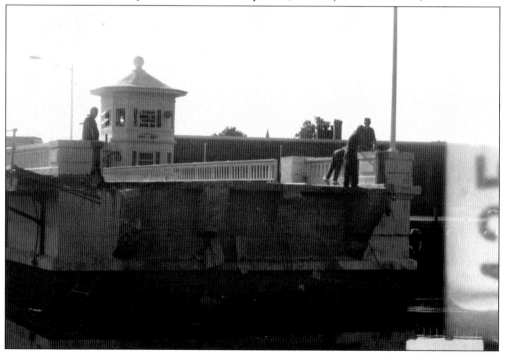

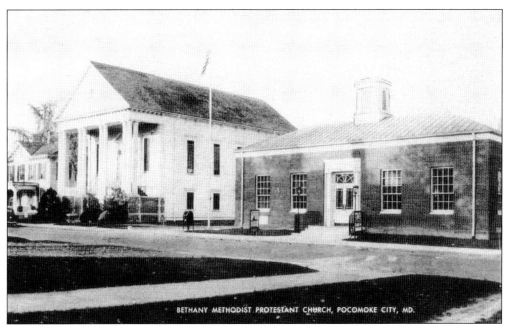

BETHANY METHODIST PROTESTANT CHURCH, POCOMOKE CITY, MD.

Bethany Methodist Church has been located on Market Street since 1882. The congregation was first organized in 1832 and outgrew two different houses of worship on Third Street before constructing the Market Street building at a cost of just $6,000. The grand, Greek-style church is pictured above in the late 1950s. To the right is the post office. On March 3, 2005, a fire of undetermined origin ravaged the building, completely destroying it (below). In the March 4 edition of the *Daily Times*, Pastor Russ Leyman was quoted as saying, "The church was not only a symbol of the congregation's spiritual identity, but also the town. It commanded attention." (Courtesy of Chris Miles.)

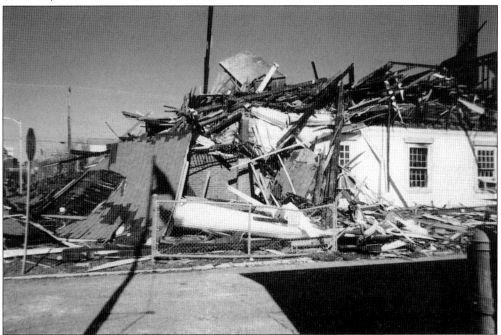

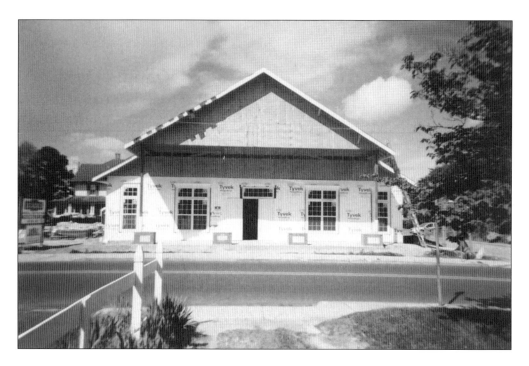

By the summer of 2007, a new Bethany Methodist Church was completed on the same property as the one that had burned and, though not as grand, is thoroughly modern and more accessible. The church is shown about midway through construction in the above image. Below, the steeple is put in place as the building nears completion. (Courtesy of Chris Miles.)

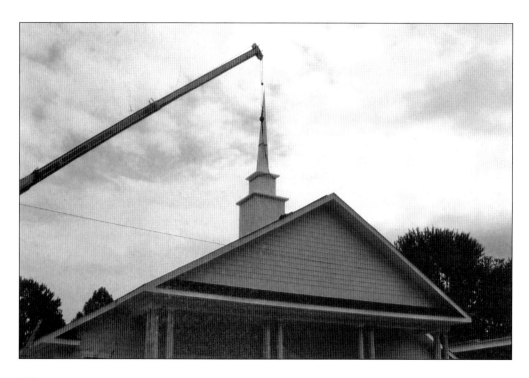

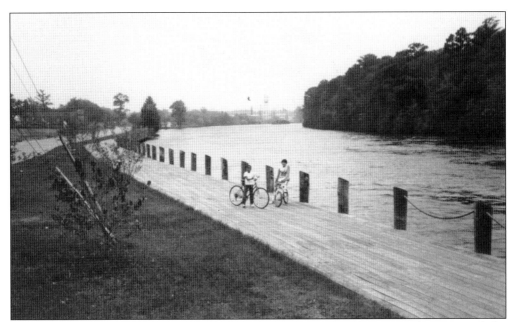

Pocomoke City has had a changing face through the years, but the Pocomoke River and the place it holds in the hearts of the townspeople has never changed. Cypress Park, an eight-acre expanse that borders the river, is a favorite area for recreation. The park provides picnic tables, tennis courts, a playground, pavilions, and boat docks. Each summer since 1976, the park has hosted the Cypress Festival, a three-day event featuring entertainment, food, rides, games, and a 12-mile canoe race on the river. This 1984 photograph shows the park's boardwalk. (Courtesy of Pocomoke City Hall.)

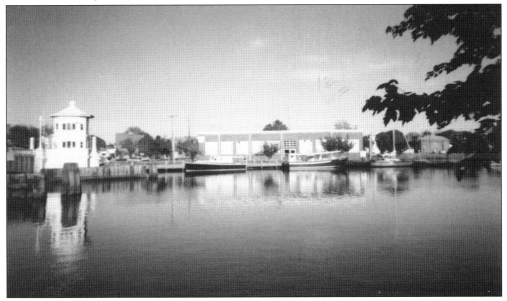

Pocomoke City's riverfront area is pictured in 2007. The drawbridge keeper's tower is on the left. The brick building in the center, once the home of the Duncan Brothers automobile dealership and empty for many years, now houses the Delmarva Discovery Center, a museum dedicated to teaching and preserving the history of the Pocomoke River. (Courtesy of Chris Miles.)

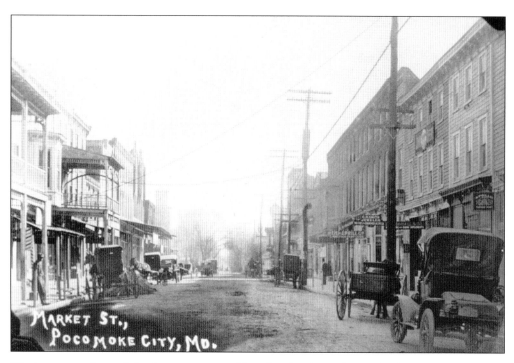

The images on this and the facing page reveal how Market Street has evolved over the years. Each shows the same view, looking south. In the above photograph, taken before the fire of 1922, the street is unpaved and the structures mostly made of wood. Taken in 1930, the below photograph highlights many new buildings on a street filled with automobiles instead of carriages. (Courtesy of Chris Miles.)

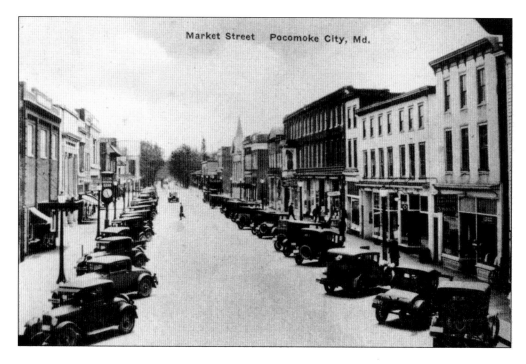

Looking South on Market Street in Pocomoke City, Worcester County, Maryland.

At the time of the above image in 1979, the business center was beginning to move from the downtown area to the busy Route 13 corridor outside of town. The people soon recognized the need to reevaluate the downtown district, and with the 1980s came the commitment to revitalize the area. By 1985, the Downtown Improvement Association had made many positive changes in the city, as displayed below. Landscaping and repaving had been accomplished, and many older buildings had been refurbished. The challenge was to invigorate the town while maintaining its historic integrity. (Courtesy of Chris Miles.)

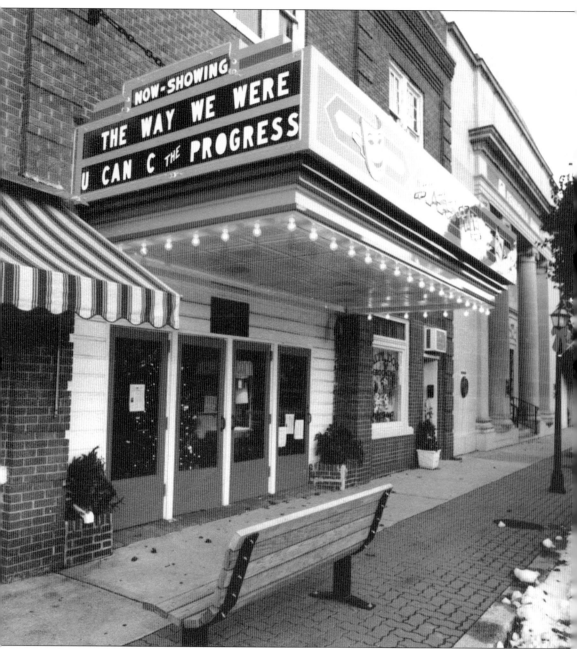

The restoration of the Mar-Va Theatre symbolizes the town's commitment to preserving the past while looking ahead to the future. The art deco–style theater opened on Market Street in 1927 and hosted movies and live theater presentations for almost 70 years. The 650-seat facility closed in 1997 as a victim of deterioration and the changing times. Once again, concerned Pocomoke City residents joined together to save a faded masterpiece; an organization formed and purchased the theater in 2002 for $100,000. It is now listed on the National Register of Historic Places, and thanks to grants from the Maryland Business Development Program and ongoing fund-raisers, the building is being restored. The theater will serve the community as a performing arts center once again. (Photograph by John C. Brinton.)

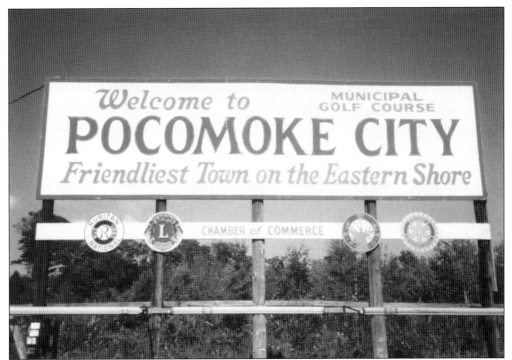

On April 22, 1922, the *Worcester Democrat* described how the people of Pocomoke City had reacted to the fires of 1888 and 1892: "But with it all they were not dismayed. Good sports that they were, and filled with the spirit of enterprise, they went at it again, only with a greater determination to do and dare. They succeeded in building a town which was not only a credit to themselves, but one which is acknowledged by all to have been a credit to the State." (Courtesy of Pocomoke City Hall.)

ACROSS AMERICA, PEOPLE ARE DISCOVERING SOMETHING WONDERFUL. *THEIR HERITAGE.*

Arcadia Publishing is the leading local history publisher in the United States. With more than 4,000 titles in print and hundreds of new titles released every year, Arcadia has extensive specialized experience chronicling the history of communities and celebrating America's hidden stories, bringing to life the people, places, and events from the past. To discover the history of other communities across the nation, please visit:

www.arcadiapublishing.com

Customized search tools allow you to find regional history books about the town where you grew up, the cities where your friends and family live, the town where your parents met, or even that retirement spot you've been dreaming about.